Nina Franková

Hollow

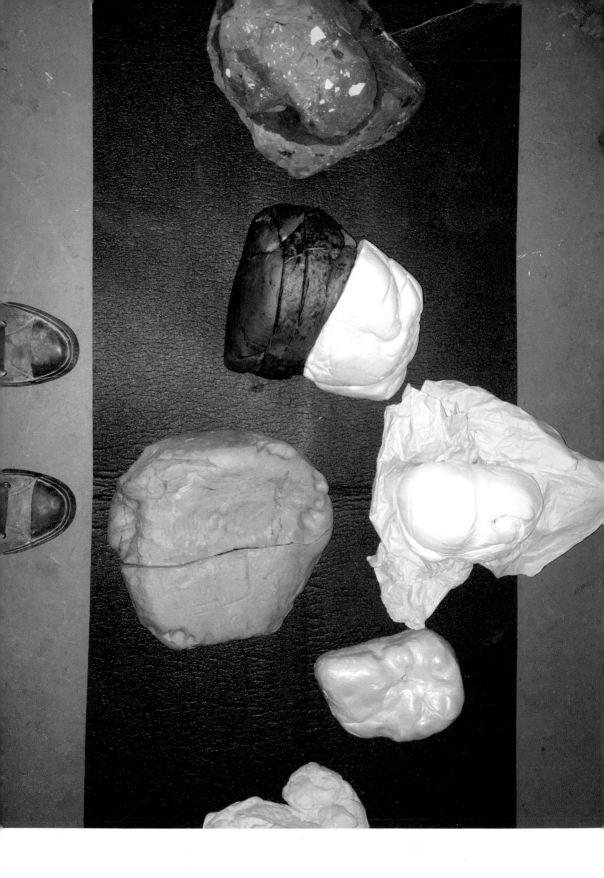

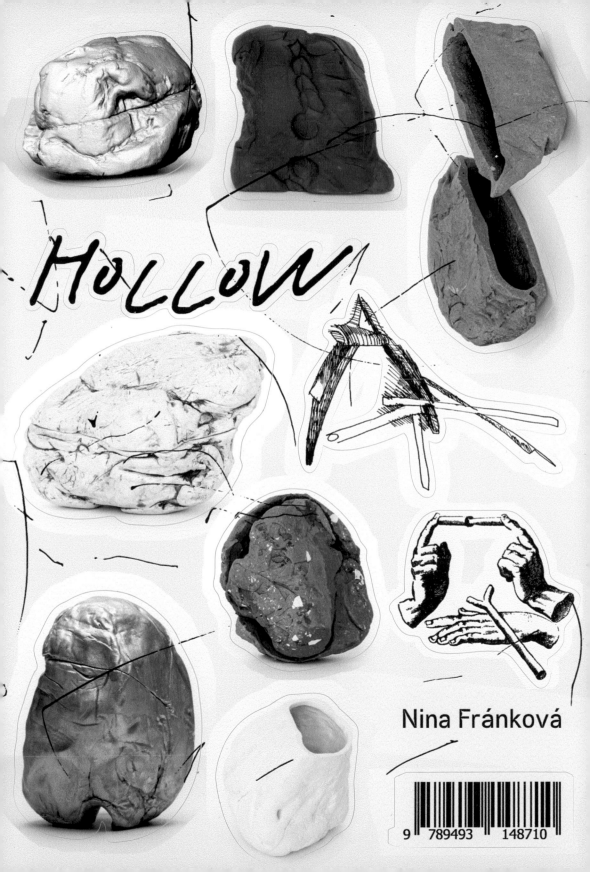

HOLLOW

Nina Fránková

9 789493 148710

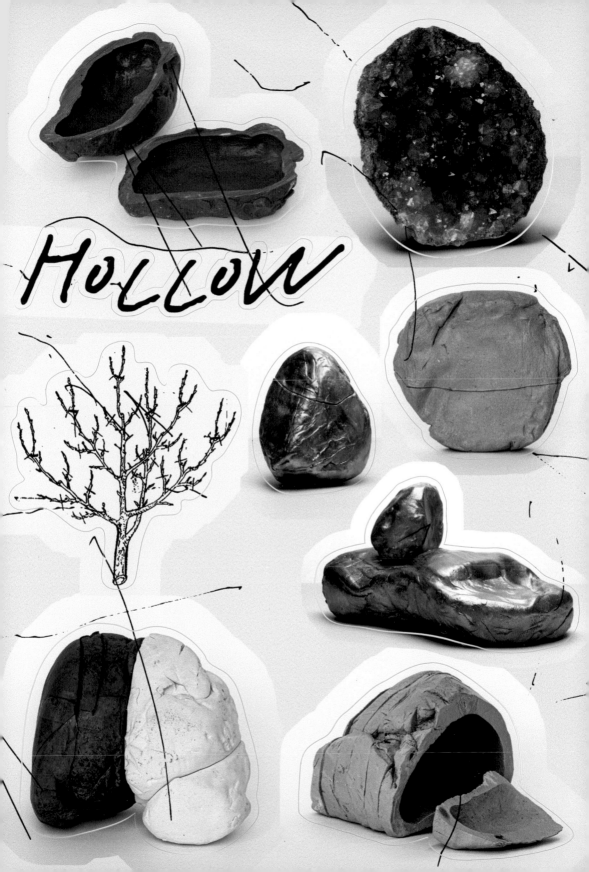

HOLLOW

HOLLOW

Dear Reader,

In this visual monograph, I will guide you through my multi-layered artistic practice with photographic documentation and an accompanying series of texts and essays. Though in my practice I mostly work with ceramic clay, I have always had a fascination with basic forms, found shapes and the residual materials collected throughout the making process. I often pause to appreciate and reflect upon the beauty of primary procedures in working with the clay, such as digging, making cavities, working with the interior of a sculpture, and my own movements whilst working. These moments of pause and reflection play as significant a role in my practice as the formed artifacts themselves, and aid me in thinking about the meaning of making new objects, whilst also locating symbolism and metaphorically taking the formation process a step further. Another source of inspiration for my three dimensional work is the taking and collecting of photographs and documentation. I am interested in the delicate balance between the process by which sculptures are created and their lives lived long after they are finished. These fleeting moments are better, and more accurately, captured on a camera than in my own memory alone, meaning photography becomes a vital step in the artistic process. As a result, photographs of unstaged scenes from both my studio and my travels have become a pivotal part of my collection of materials whilst in the process of making this book.

In this monograph, images of my work and process are accompanied by a selection of self-written and commissioned texts. Each text activates important themes that are attached to my work, these themes are: Performance without a Spectator, Unfinishedness and The Art of Becoming. The three central topics which form the basis of this visual monograph were taken as a source of inspiration by invited contributors: Kris Dittel, Denisa Kollárová, Pedro Moraes and Anne Grøtte Viken. The structure of this monograph is fluid. Textual contributions and essays are interwoven with studio photographs of sculptures from the Hollow series, amongst other photographic documentation. In correspondence with the photographs I have included a number of Short Textual Notes which are placed throughout the body of this publication. The monograph begins with The Absence of the Body by Kris Dittel, which contemplates my artwork Hollow, and centres the theme of unfinishedness, directly referring to ceramic sculptures as conceptual works. The Babe in the Woods, Made up Crafts and On Unfinishedness follow, where I ruminate upon my own methods of working. These shorter texts then pave the way towards Annee Grøtte Viken's short, speculative story and Denisa Kollárová's essay, Permaforming based upon her own memory of Bruno Latour's Circulating Reference. Both Annee and Denisa's works reflect upon The Art of Becoming. Next comes the philosophically-focused, fictional text by Pedro Moraes. Finally, The Cognisant Clay, the second contribution of Anne Grøtte Viken concludes the contributions to this monograph.

I wish for this publication to capture the essence of my work and artistic expression, which understands sculpture as a record, and as proof of process rather than a mere resulting object. For me, sculpture has always been much more than the presentation of ceramics on a pedestal. As a result, this monograph is designed to lead you through its pages, to encourage you to look deeper into the details of the projects, to grow curious and find new connections between information sources that appear different in their form and focus, yet are interwoven and connected nevertheless. The hope is that as you make your way through this publication you may well completely forget that there are ceramic sculptures at the beginning of its story, and instead care more for the processes that surround them.

I wish you a pleasant reading experience.

Nina Fránková

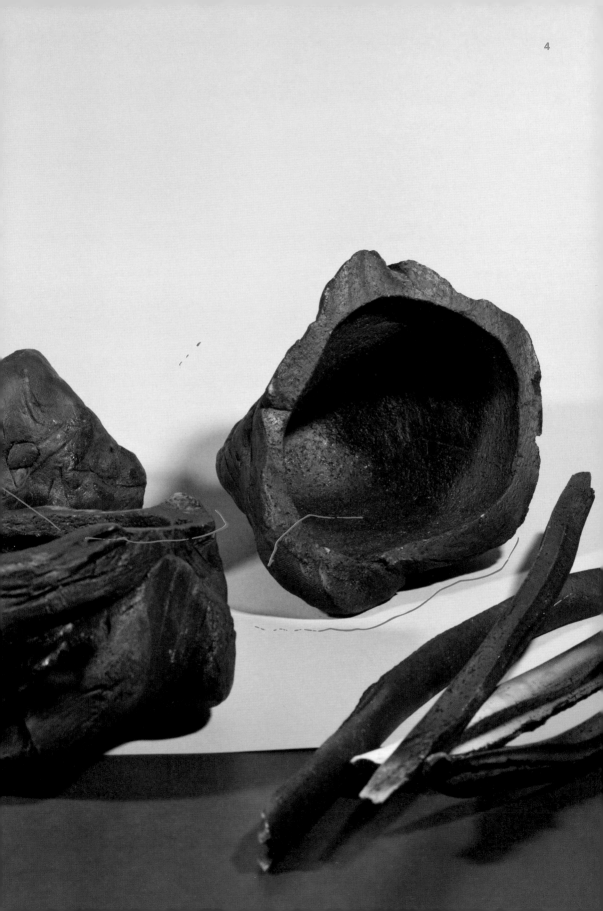

4

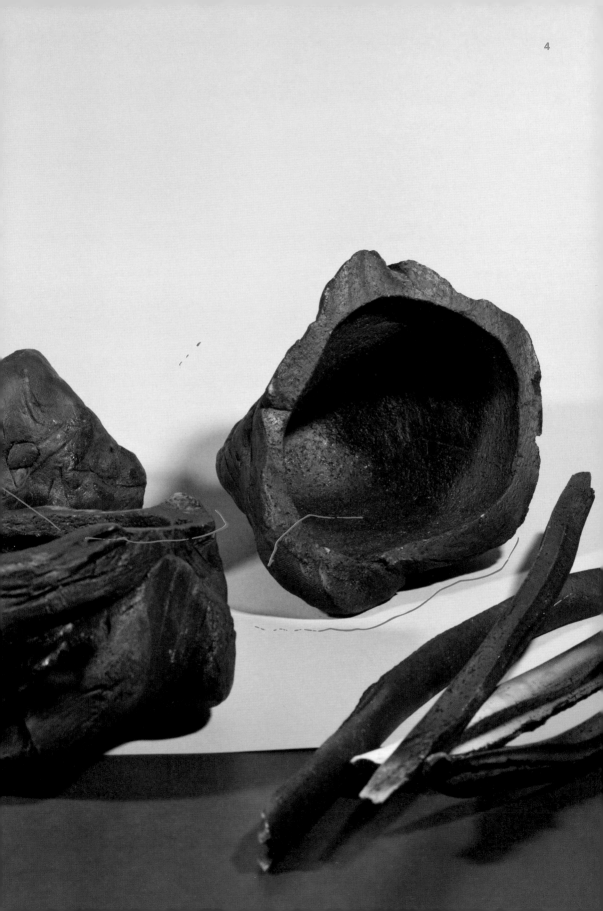

The sculptures in the series Hollow resemble stones in a variety of sizes. Some pieces were made by cutting in half and hollowing out shaped lumps of clay, for the sake of preserving the outside body. In the last few years I've been focusing on making ceramic sculptures in primary forms, looking at the creative process from a psychological standpoint — as a ritual and as part of becoming. The point of departure for this research is to take the conventional processes found in the production of functional ceramic objects and to replace these technical procedures with the production of sculptures. Through this procedure the functional ceramic objects lose their original meaning so as to get twisted and transformed, allowing new meanings to be created. The clay was purposefully treated with other experimental materials, essential oils, make-up, charcoal, petroleum jelly mixed with pigments, or oil paint was applied to the surface. Binding during drying, burning in fire, smoothing the inside, shaping the outside, or hanging on ropes — these processes refer to ancient methods of preserving the dead and sacred objects, practices cultivated in medieval witchcraft, and Ayurveda healing treatments.

One of the central references for Hollow is the ancient conservation methods of sacred objects. The application of petroleum jelly (Vaseline) with or without pigments, on fired or unfired clay. Preservation is an interest of the project insofar as it functions as the hedging of natural processes, like rotting or decaying. In the context of Hollow, preservation is a strategy to confer more meaning to the objects, to make them last longer. The technical procedures of preservation are integral to ceramics, and in that sense there is polyphony in the understanding of preservation. The treatment that finally endows ceramics with durability is fire, which provides long-lasting value to ceramic materials, making them harder and impermeable. By eschewing the preservation of ceramics, the work ceases to be about formal glazes on fired clay bodies, my technical skills or its eventual display. It is instead about fleeting moments that are not going to last forever. It is about sensitivity and observation. These records and the production of this archive in a certain sense becomes the main subject of the work. Instead of understanding the main object of my work as the end products, I choose consciously to accept their flux as my object of inquiry.

Photography has been present throughout this process, allowing me to document the different stages in the development of my work. At this point I have an enormous archive of images documenting my artistic process, including images of unfinished pieces, installation tests and photo-notes from "the making of". This archive means I have a broad understanding of my practice and allows for an image of precision that is disconnected from rationality.

This collection of images documents precisely the moments of transformation, as they are present in nature. Absolutely fleeting and inconspicuous in their absence.

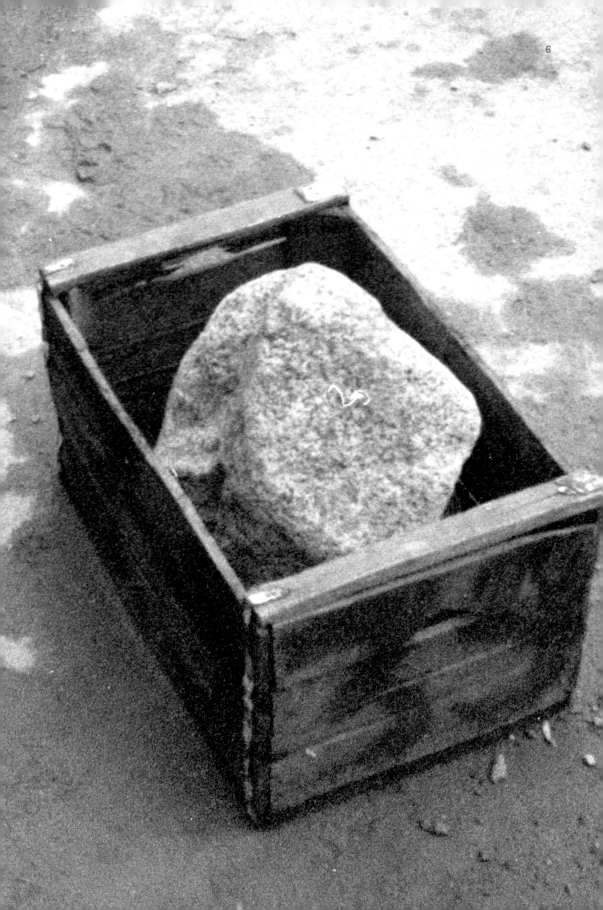

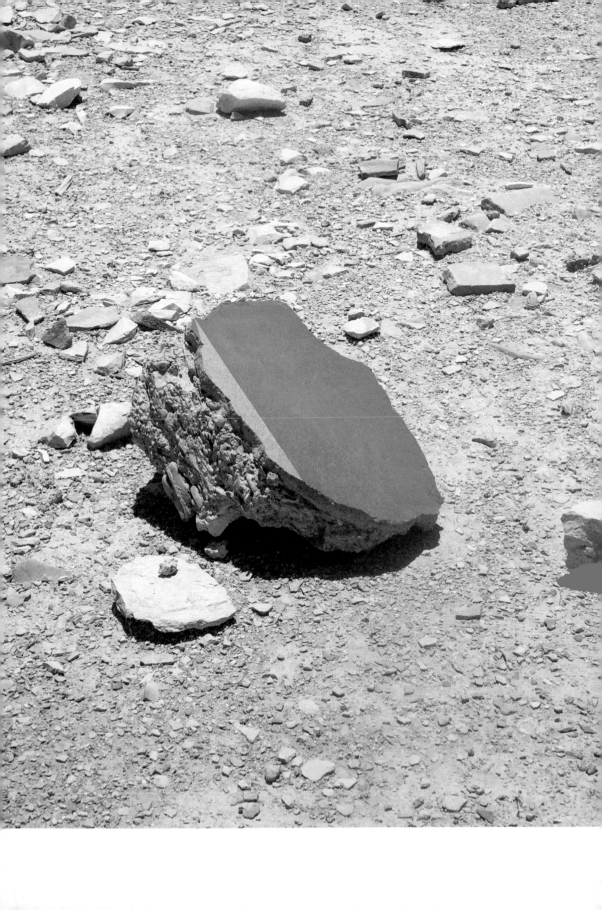

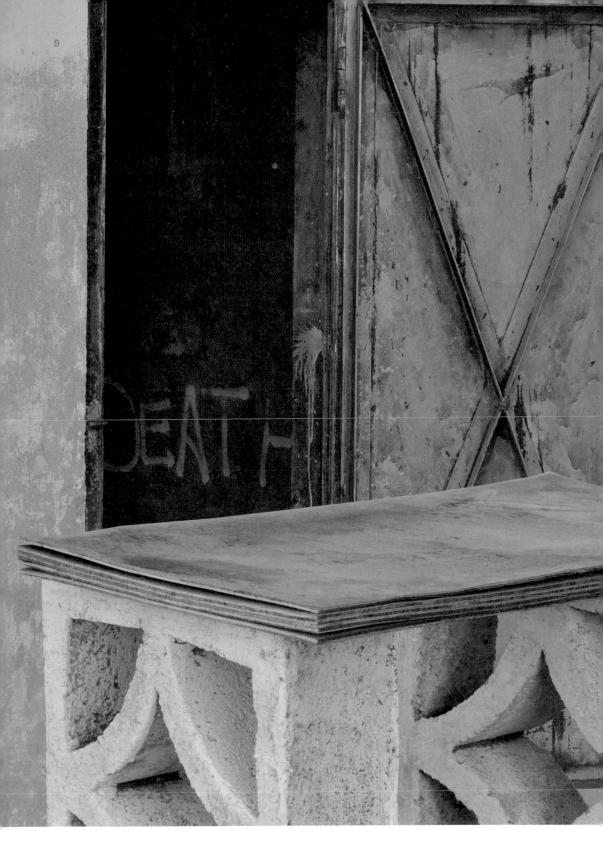

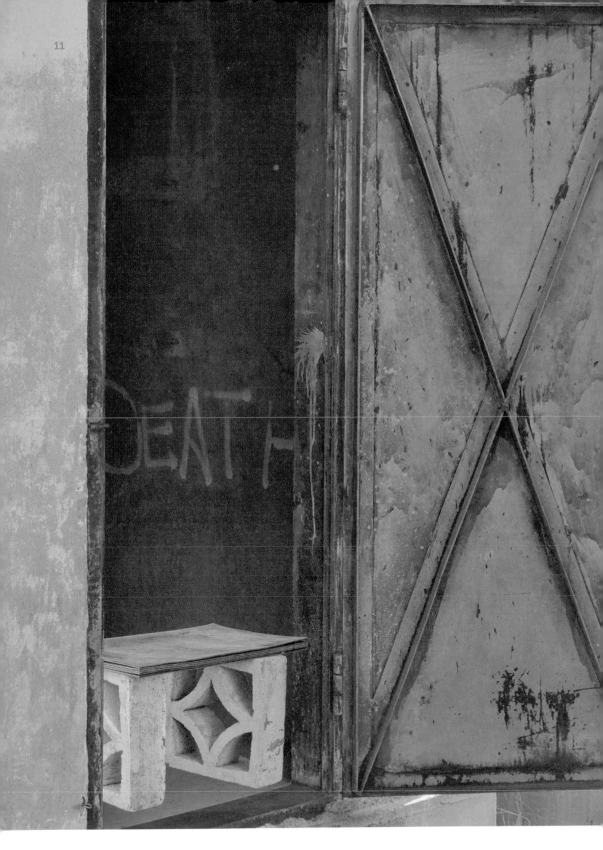

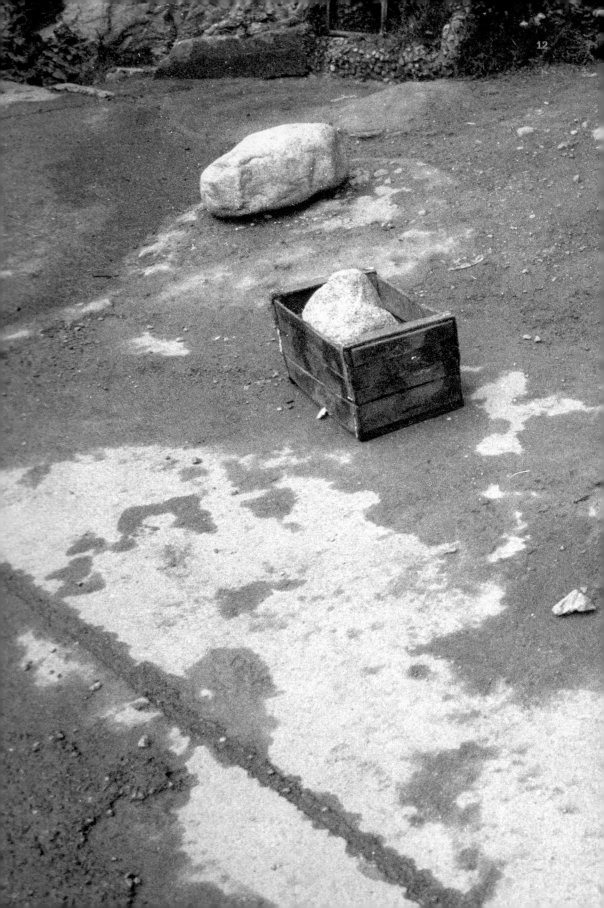

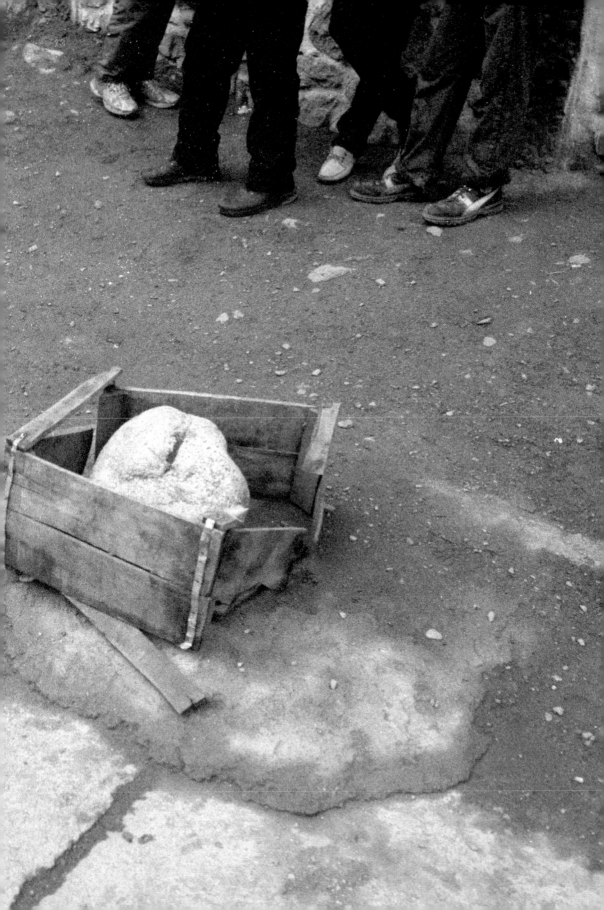

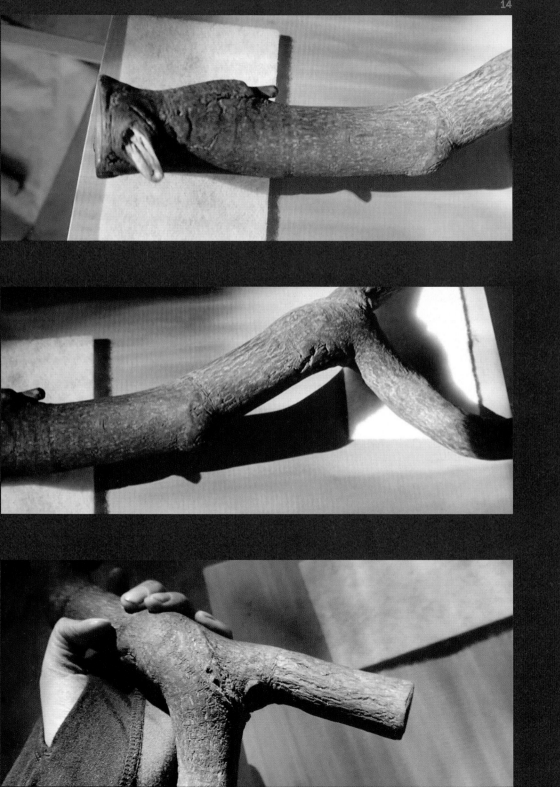

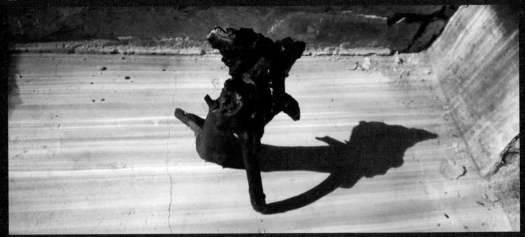

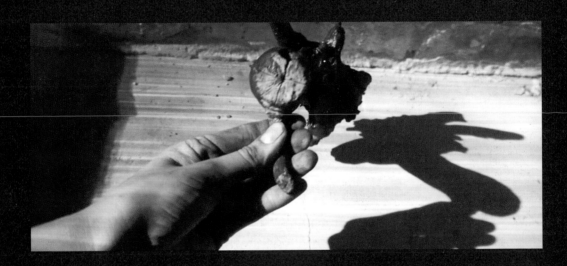

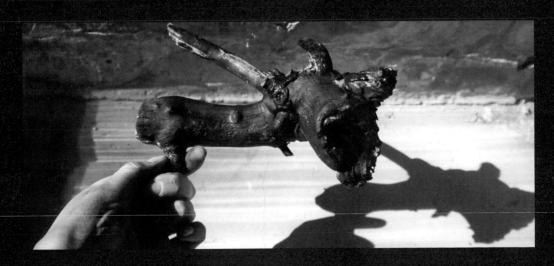

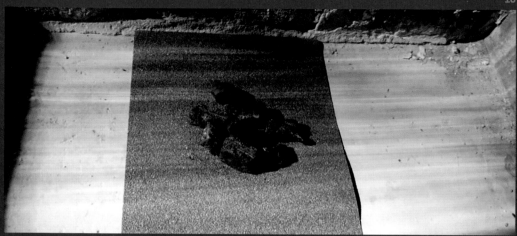

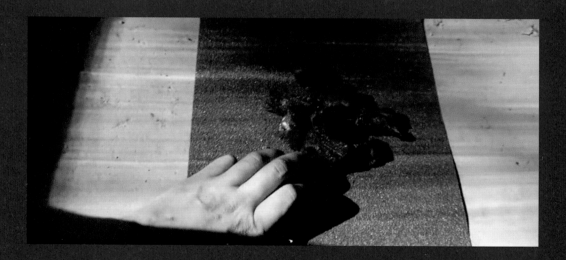

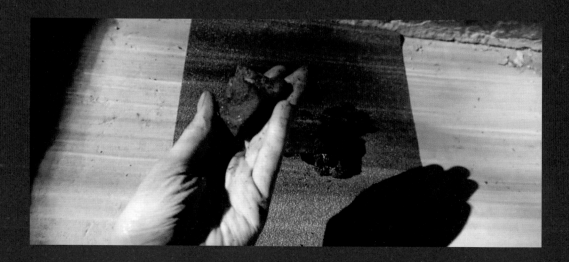

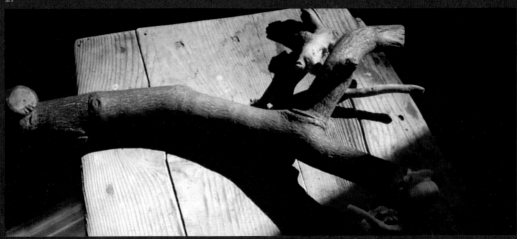

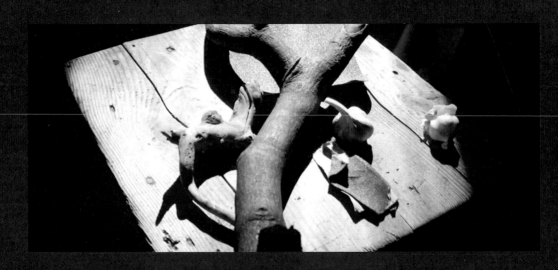

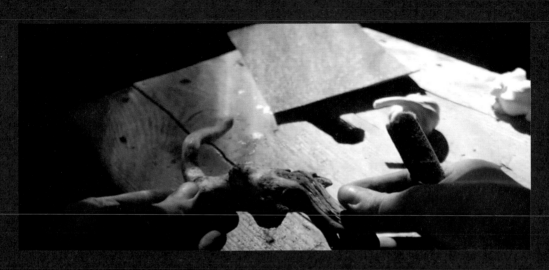

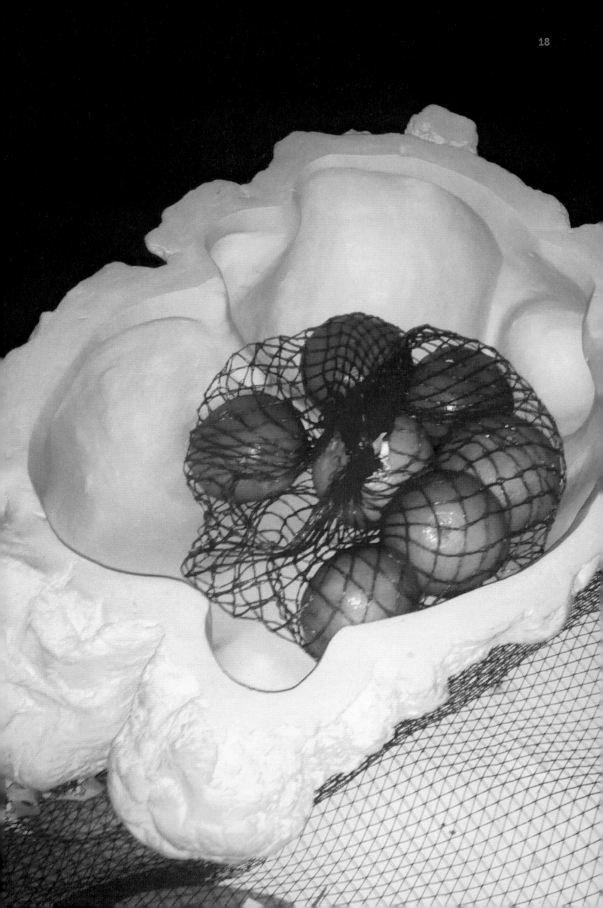

Kris Dittel

A hollow object is one that has been shaped gradually by natural forces, such as wind, water, erosion; or emptied by an intended activity, for instance a shell of a coconut, carved out for its sweet juice and flesh, or a ditch in the ground dug for the purpose of gathering underground water or rainfall. A crusty shell and a hole in the ground are containers, with their inside removed awaiting a substance to fill them.

Hollow things connote absence.

Ceramic sculptures can be as much about material, form and tactility as they are about hollow spaces. On the pages of this book, at first they may appear as simple lumps of clay, ranging from the size of a fist to voluminous objects that seem too heavy to lift. They were laboriously formed through movements of the hands and the entire body: pushed, punched, thrown, rolled, until they arrived at their final shape. Some of them have received a shiny glaze or have been treated with beeswax, tempting the observer to run their fingers along the object's surface.

The sculptures become most alive when placed in everyday situations, surrounded by other objects. Resting on a piece of foam on the studio floor, on a desk between notebooks and used coffee cups, or holding bags of ripe fruit. When displayed in a neutral, brightly lit interior with white walls, ready to be photographed, the hollow objects occur in need to be used, to be touched, to carry something.

The absence of things, however, does not equal lack.

The insides of the sculptures have been carefully carved out, turning them into a hollow shell, a holder, a container. "The earliest cultural inventions must have been a container to hold gathered products and some kind of sling or net carrier", Ursula K. Le Guin reminds us in *The Carrier Bag Theory of Fiction* (1986). Containers are ancient technologies, they are cultural carriers that may hold other objects, treasures, stories, memories.

When such objects are attended to, they "do" something.

They may ask to carry other things or tell the story of their making. The maker's body is not there, yet its presence is felt through the imprint on the sculptures, suggesting the care and force which moved, pushed, pressed them into their final form. The sculptures encompass the intensity of their formation and become substantiations of the choreography performed alone in the studio.

Even though absent, the body still manifests.

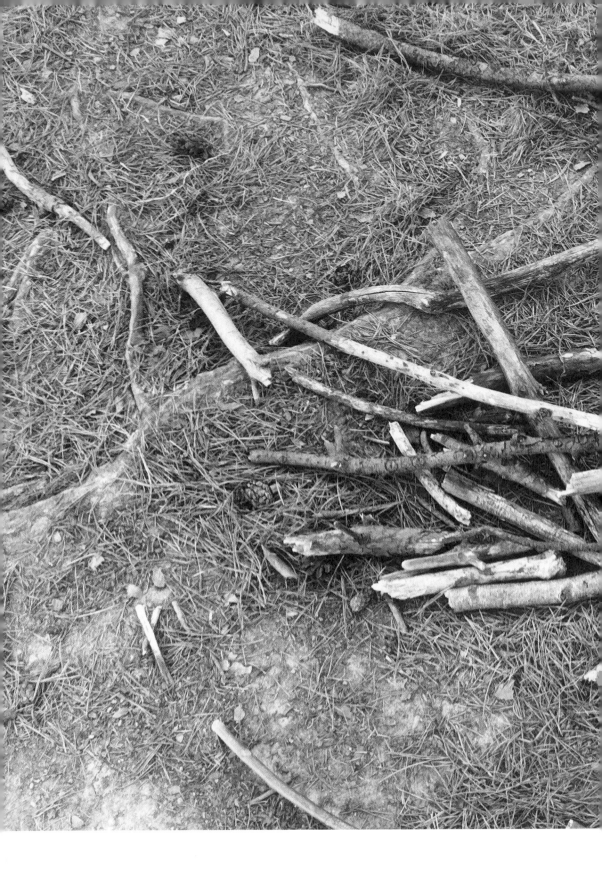

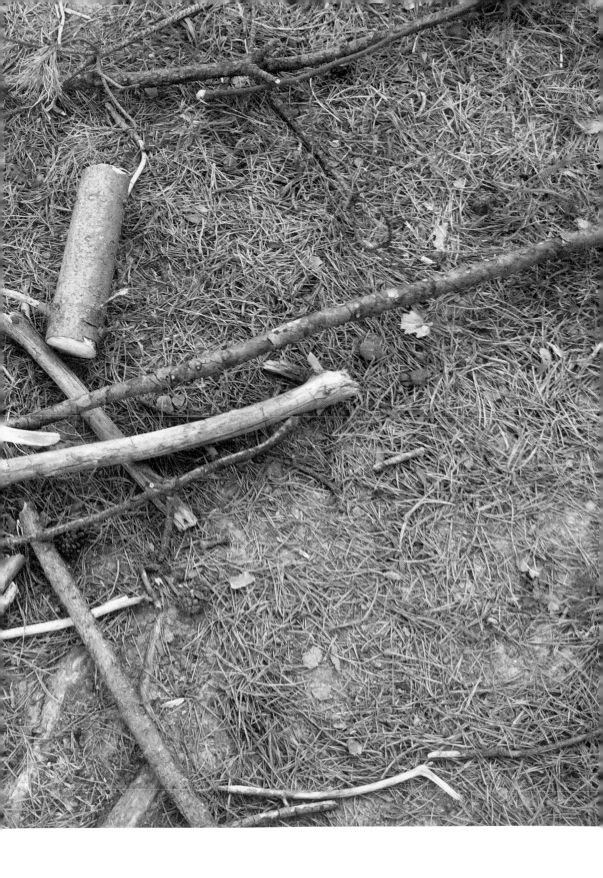

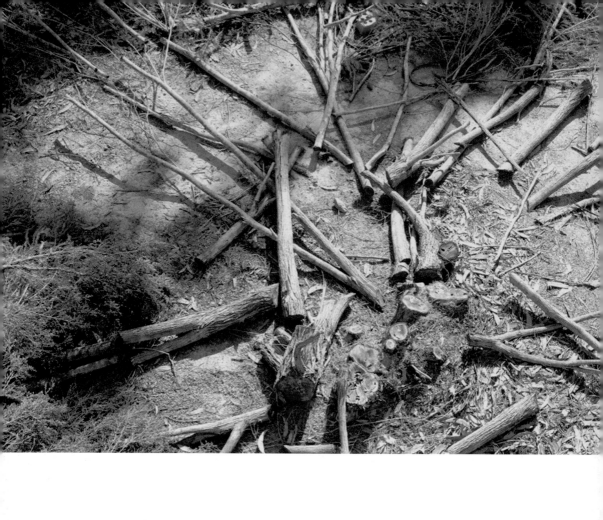

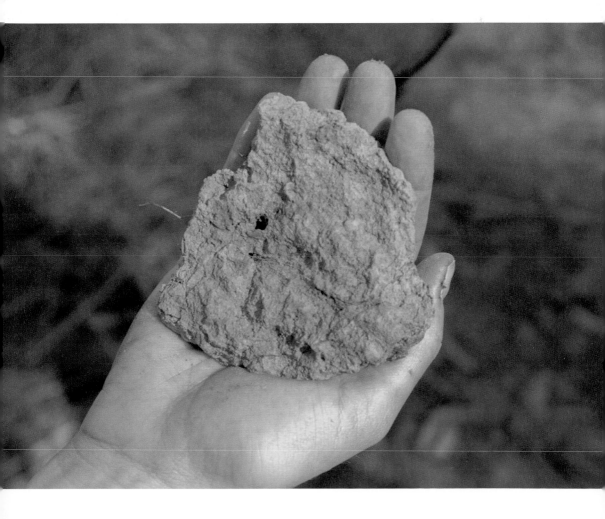

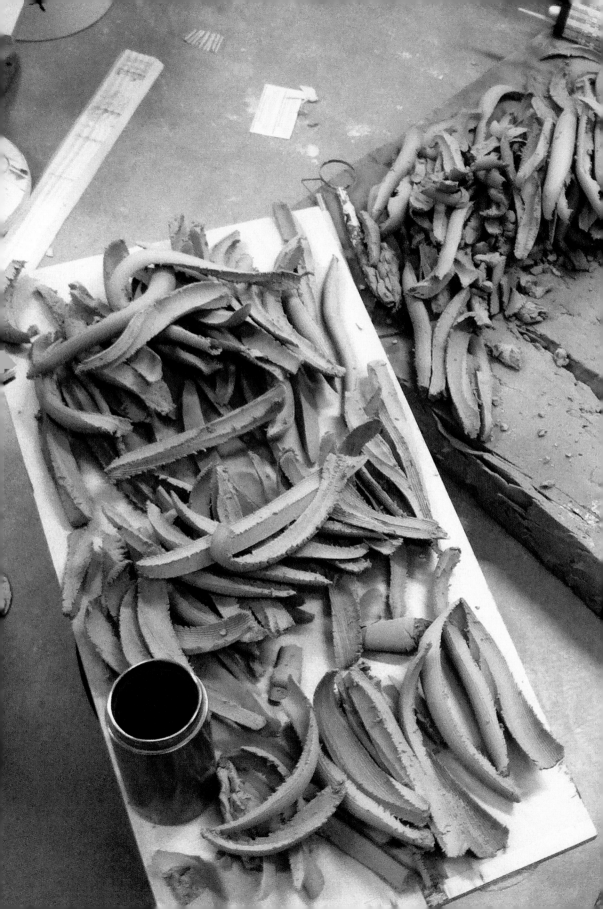

Sticks #7

(un) organised wood that looks like it
has been touched by a human hand
at least it was touched by the human eye

seen and captured

put into context
given meaning

compared to something
that already exists
something similar

clay sticks

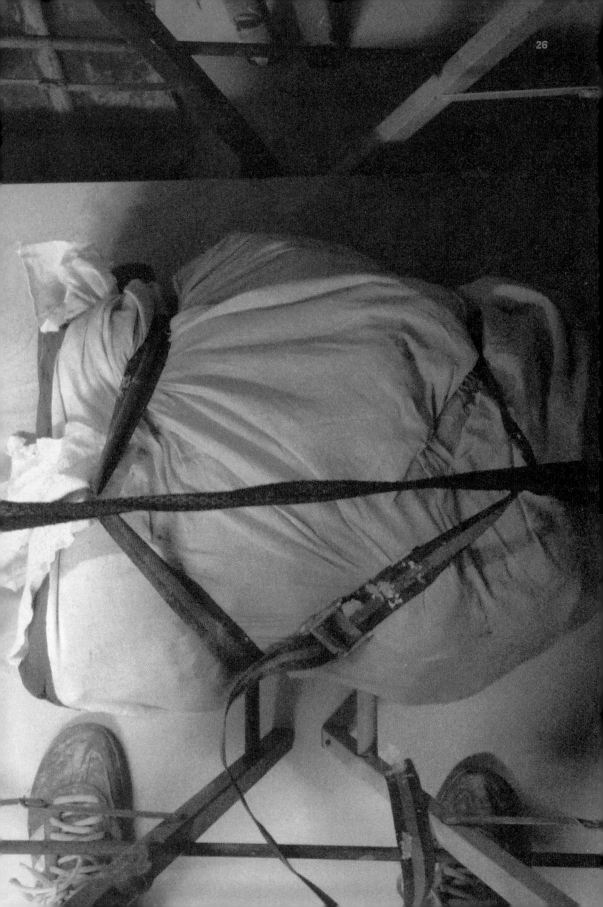

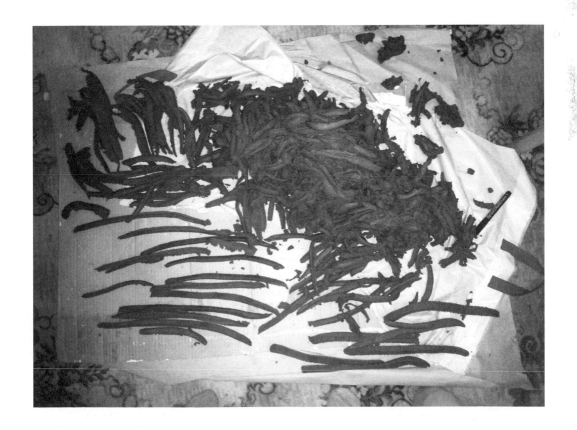

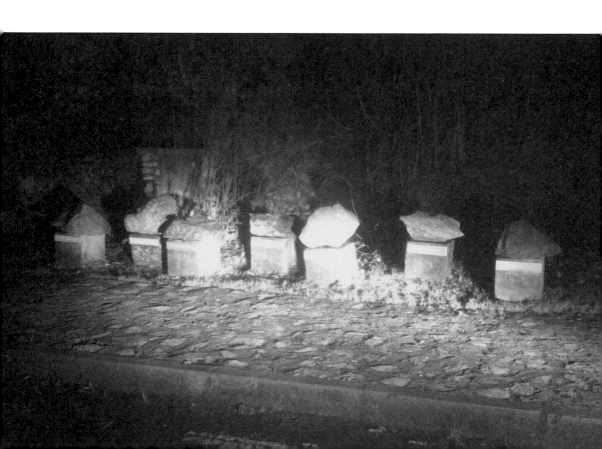

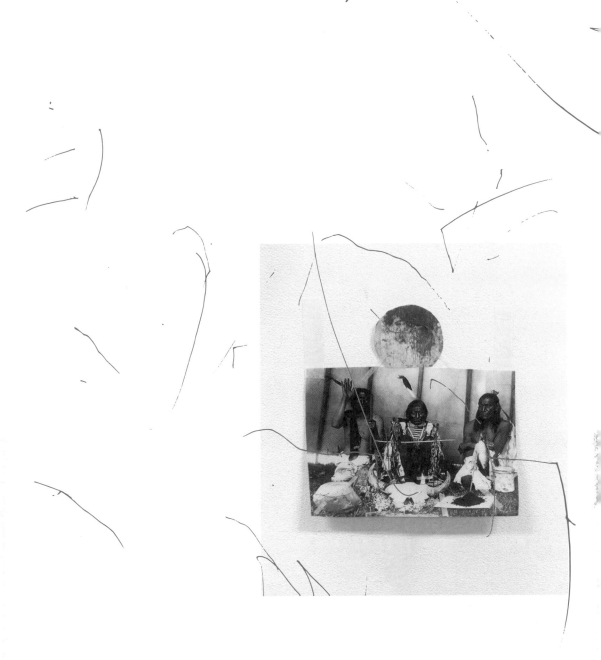

Seeking solitary objects with charisma. Finally several
are gathered. The characters act as an appropriate
group of props. The entire staged situation requires
absolute personification during any given moment.

The body mediates and moderates.

Moods are fluid energies circulating between
structures and properties of matter.

Surfaces, shapes, origin, smell and consistency
act as letters in the alphabet. Hands are a dinosaur.
Oversized monsters that act for the sake of survival.
It happens to be an inevitable movement.

While objects are manipulated they cannot fight
back having been removed from their original places.
They are not able to run or scream.

Being privileged by taking part
they succumb and become a sacrifice.

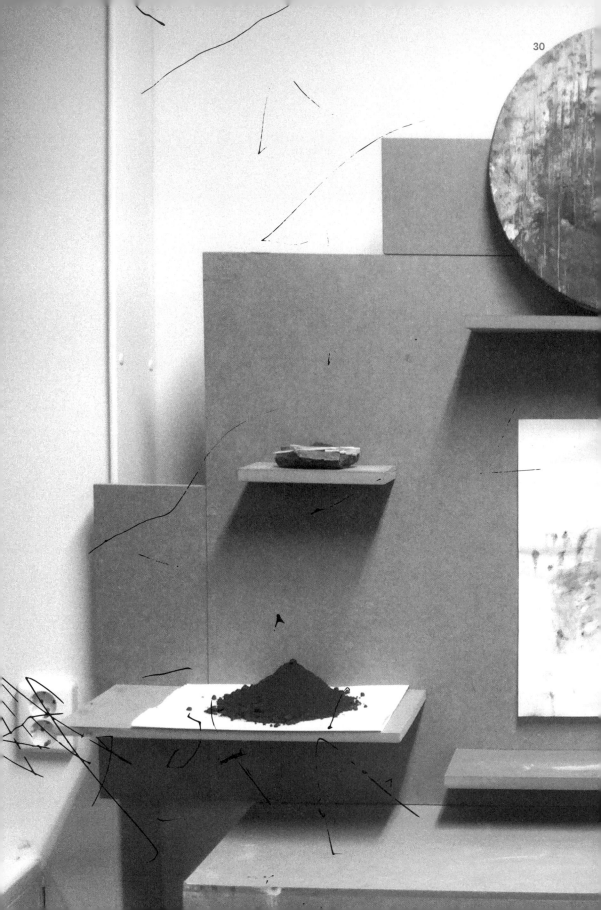

altar of materials

wooden board for mixing Vaseline and pigment
the largest jar of Vaseline

fragment of fired pottery as a mixing plate
handprint on A3 paper, iron oxide with Vaseline

hands

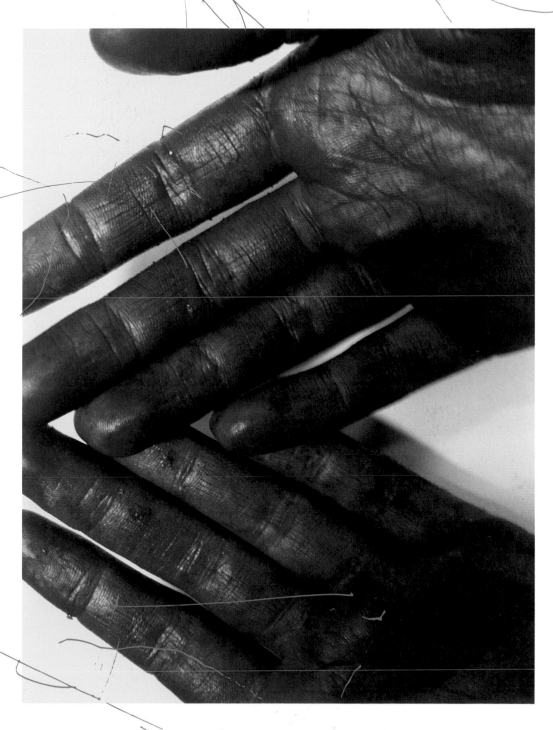

my hands after applying vaseline
and iron oxide on a Deer Head sculpture

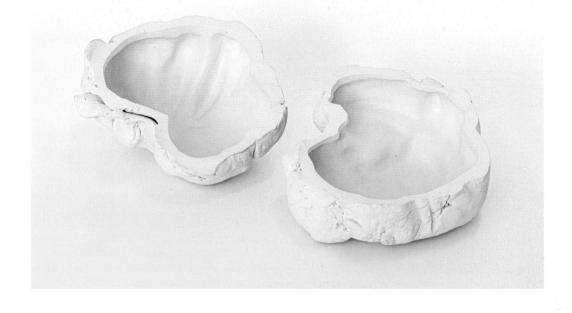

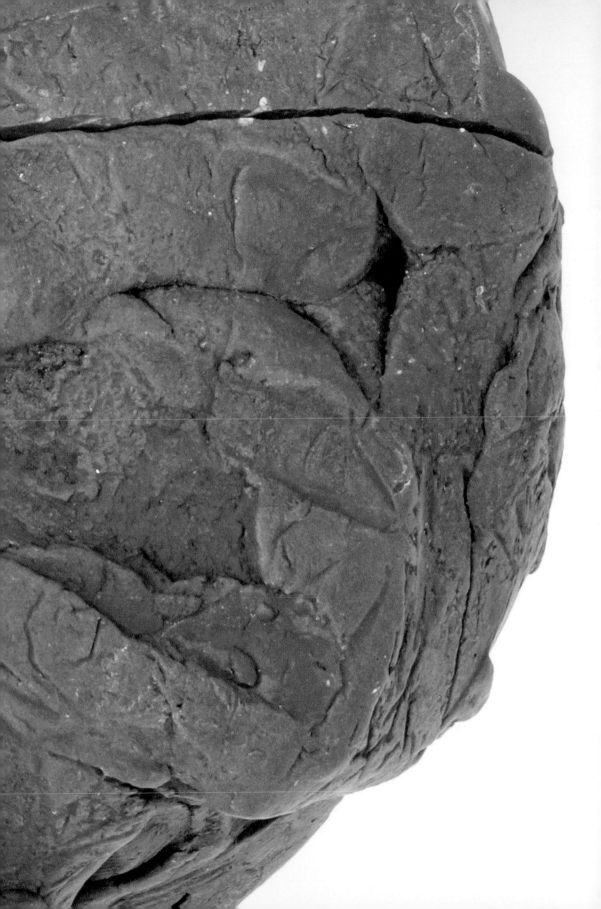

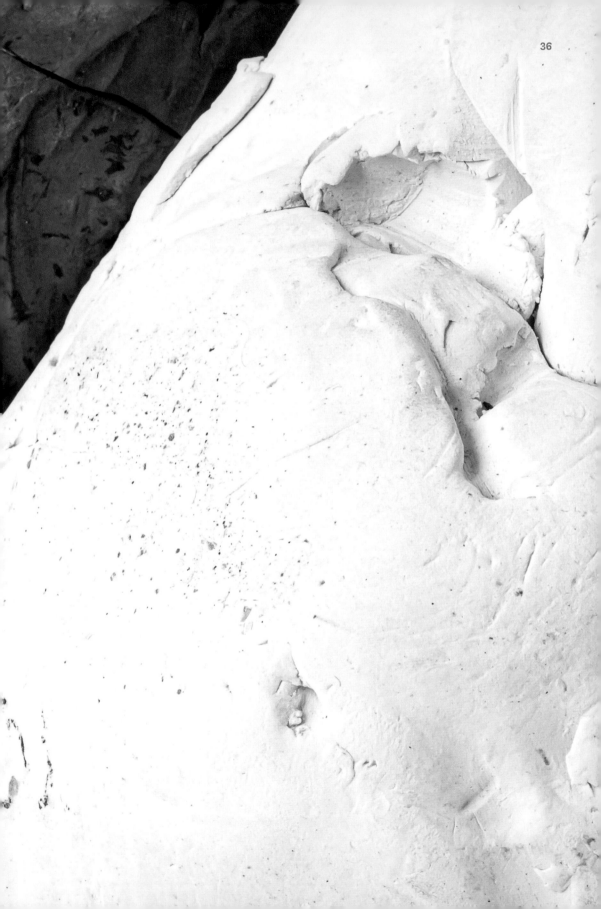

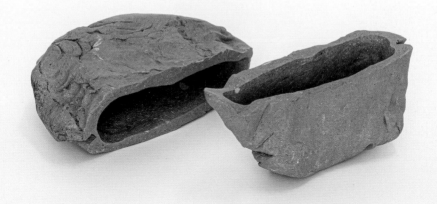

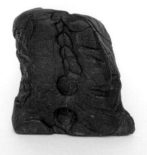

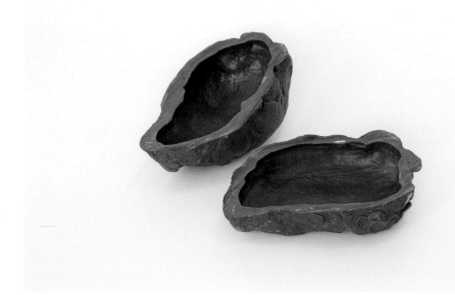

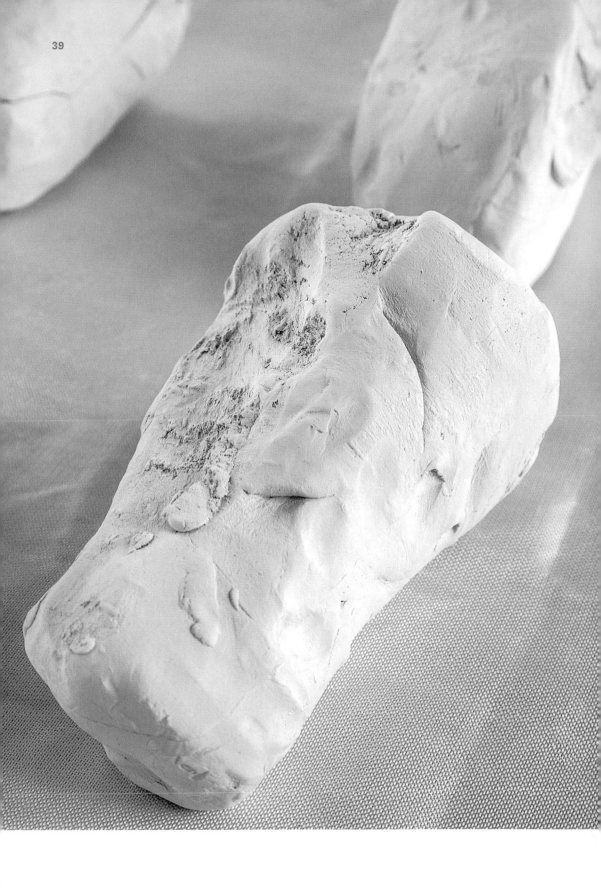

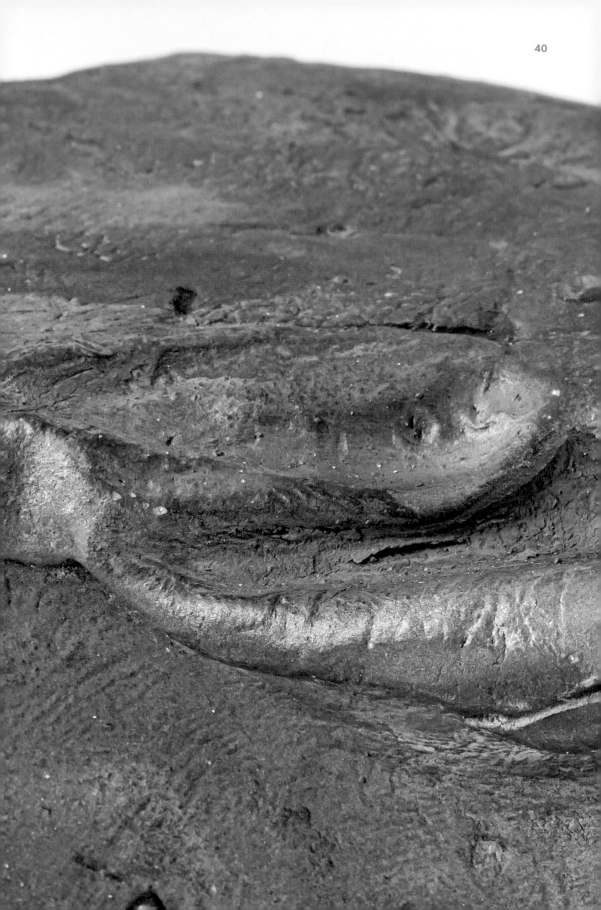

The art of becoming

*

("*Something like the memory of a tall monument
that seems taller because it is a memory.*" [1])

It leant itself to poetry but the stanzas wouldn't cooperate.
 It insisted on being a poem but wouldn't become one. It
refrained from explanations but wanted desperately to be
understood. It got taped, collaged and hammered. Thrown,
resisted, poked and painted. The t-shirt was all messed
up and the door was broken. She looked at me, — to make
something come alive doesn't mean it will go on living.

*At the mouth of an abandoned mine tadpoles drift in a
cloudy turquoise pond.
 Closer to shore they make up an erratic pollywog
porridge where the aquatic amphibians metamorphose,
grow limbs and learn to breathe. A volcano bursts out
into the open and across the marsh a faint but alert
siren is carried by a northbound wind through the
muted landscape.*

It hung underneath the sink for weeks
but nothing happened.

*I read /ˌmɒrəˈtɔːrɪəm/ tasted the sound and imagined
a ritual of mourning.
 The syllables drew an image of a circle carved onto
a peak and a number of objects were held aloft tracing
the circle an arms length from the summit. The objects
hanging in the air followed my presence with a glazed
gaze and an acclimatized indifference to whether or
not something actually would take place.*

It wanted to be carved out but started to itch.

*From the face of a mountain three pebbles roll up an
avalanche. Below, a sunflower seed considers the soil*

1. Clarice Lispector, Água Viva,
(London, Penguin Classics, 2014), p.87

and cracks open. Above, a chrysalis sways unfazed from a half eaten leaf. Shape-shifting superpowers grow in pregnant silence.

It asked for nail polish but couldn't choose the right tone.

The goal has always been to launch the next generation, to end one's own with the reproduction of the next. Taste the tone of the mating call; it needs to be pitch perfect. Bodies make ripples in space to find their kin: the water pulsates in sync with our beating heart, we adjust; get comfortable and lean in to hit the right chord.

It wanted to fall into place but couldn't fit in.

The lacquered black bow makes an elegant figure as it points to the sky and shoots a thin translucent string through its metal rings and releases a lure into those made by the rain. Its impact reverberates shrill-deep across the lake as if in the hands of a gong master. The tiny body of stainless steel swims beautifully. I reel in slowly, pause for a fraction of a second then continue. I repeat, watch it wiggle, sink and pull through. I watch it move steadily towards me, swim with the waves and become water as the rhythm replaces its body and crepuscular rays no longer distinguish one from the other.
It winks to the sun, exits the water and ceases to exist.

It was filled with love.

The art of becoming
Annee Grøtten Viken

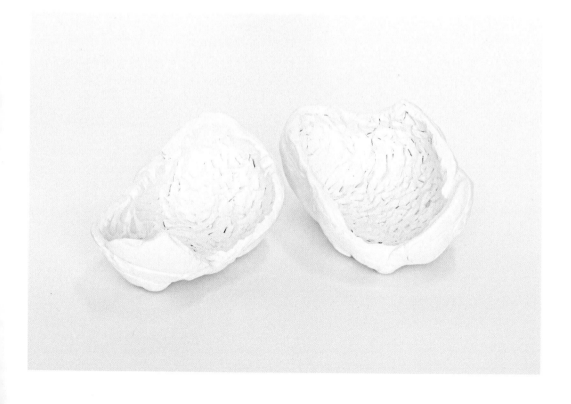

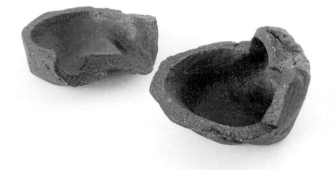

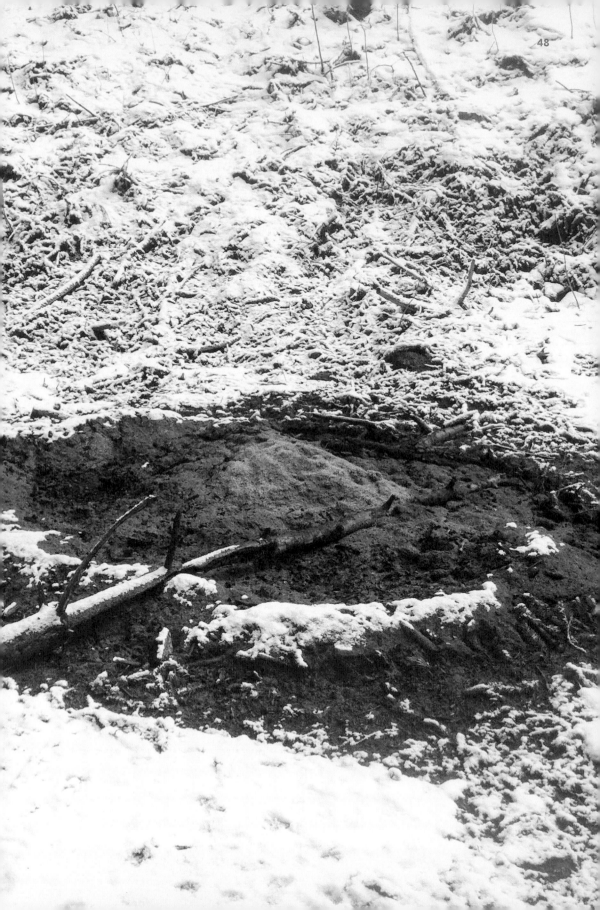

Made up Craft

Interested in mythology
Not ritual but
Using it as a context

There is something sophisticated
in the way you arrange the things

Things relating to each other
Peel, slice, something rough
A lot of these objects are both really considered
and really delicate but also really rough and fast.

And it's just like a peel and slice

And yet
There is preciousness in how they are treated
as evidenced by just looking on both of these

It is nothing, they are just pieces of clay.

But how you treat them
makes them precious.
And abuse them
with preciousness
There is this carelessness
but so much care and
it is mysterious and intriguing
because what's inside of it

Working with basic matter
spiritually and physically.
It is very close to the art of
the primeval man,
the playing of children.

You are creating with a clean head but
with your own intellect. I think you give
back to the material its own original qualities,
You are discovering its true beauty. It is so
simple but at the same time I have
never seen anything like this before.

It is very new but at the same
time something very closely known.
It is like work about some eternal, absolute topic.
But it has astuteness and intelligence

Basic matter
Ideological
Praformy — Primary matter / primary form
Early forms.

(recorded conversation with an observer)

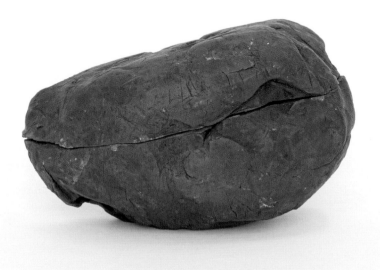

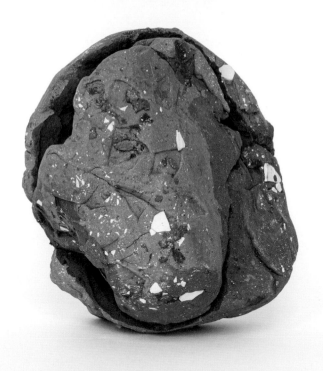

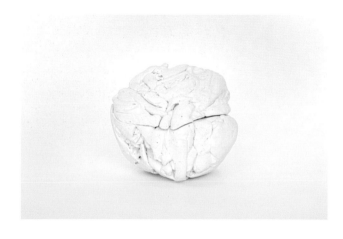

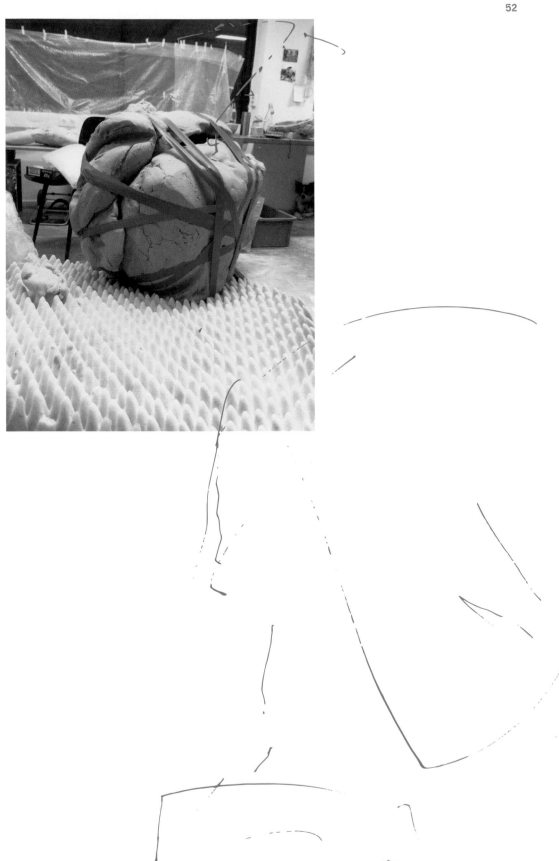

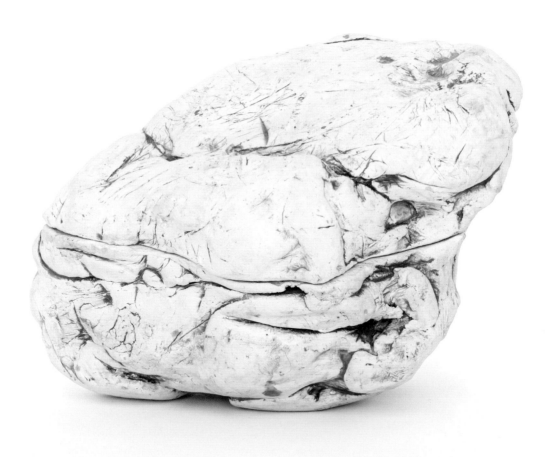

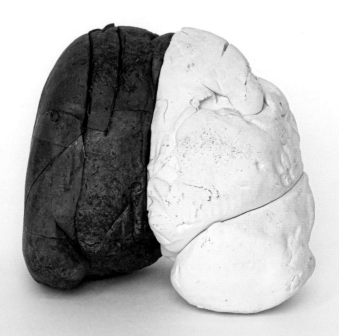

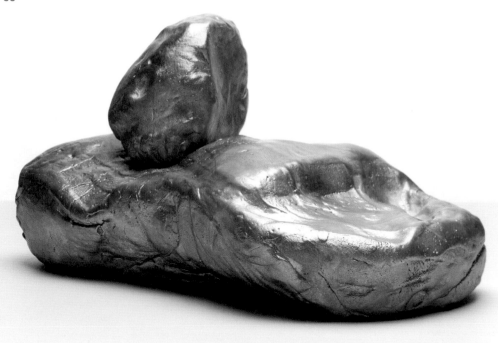

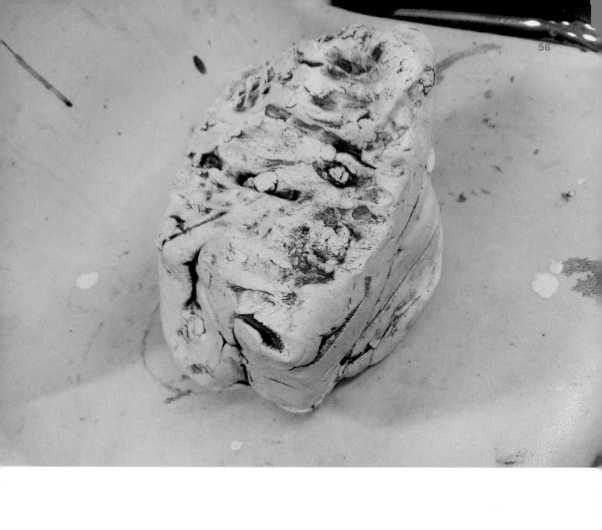

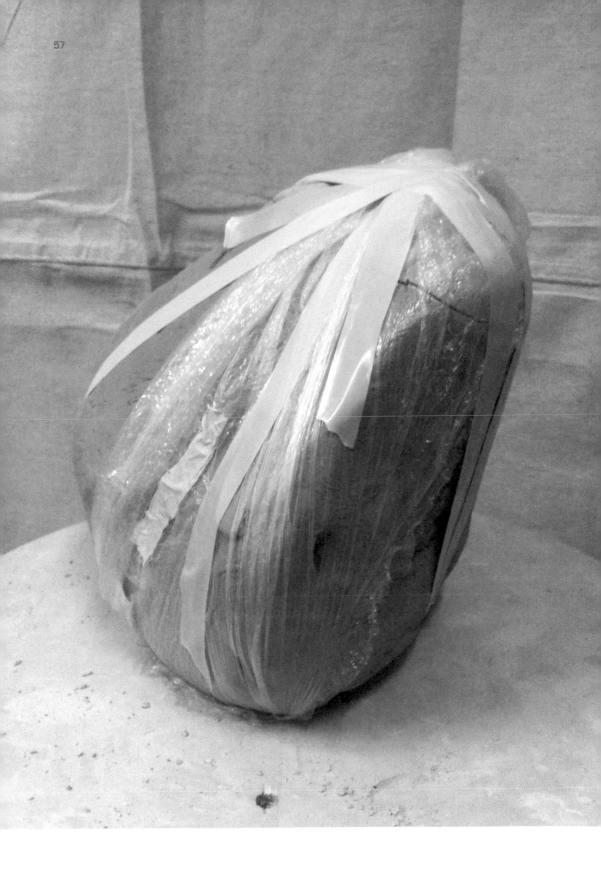

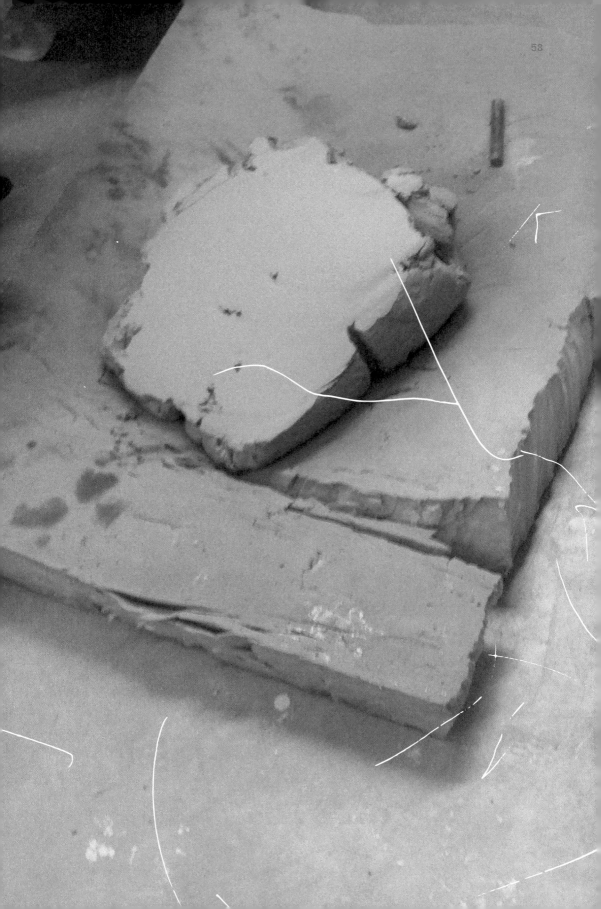

The shaped pile of clay is freshly cut.

Both halves of the stone lie on the foam.

This act should be performed with special care
and the incision should be made in the exact position.

Before splitting, the body of the clay must be leather-
hard. If it is too soft during cutting, both pieces
will not retain their shape as if they were together.
During handling, they can disintegrate and reshape.
After they have been split, excavated and dried,
both parts may not fit exactly.

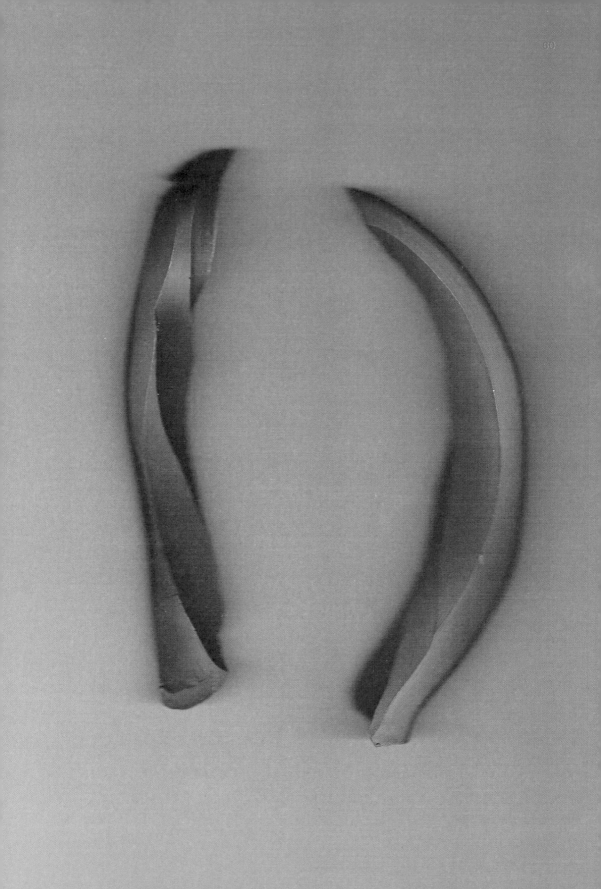

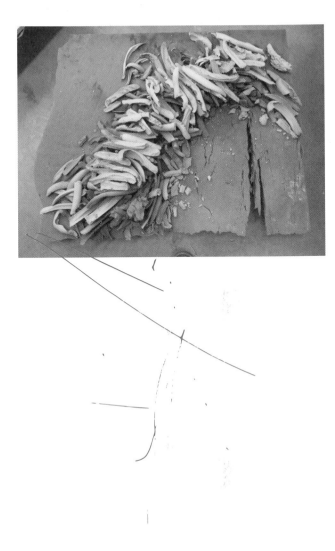

INSIDES — new value

During the excavation,
the clay sticks collect in one place.

This automatic choreography of working hands
spontaneously creates something new and valuable.
Installation.

The collection of residues in mechanical, repetitive
movements. Repeated movement produces a by-
product. Waste material. What are you doing with
the leftovers?

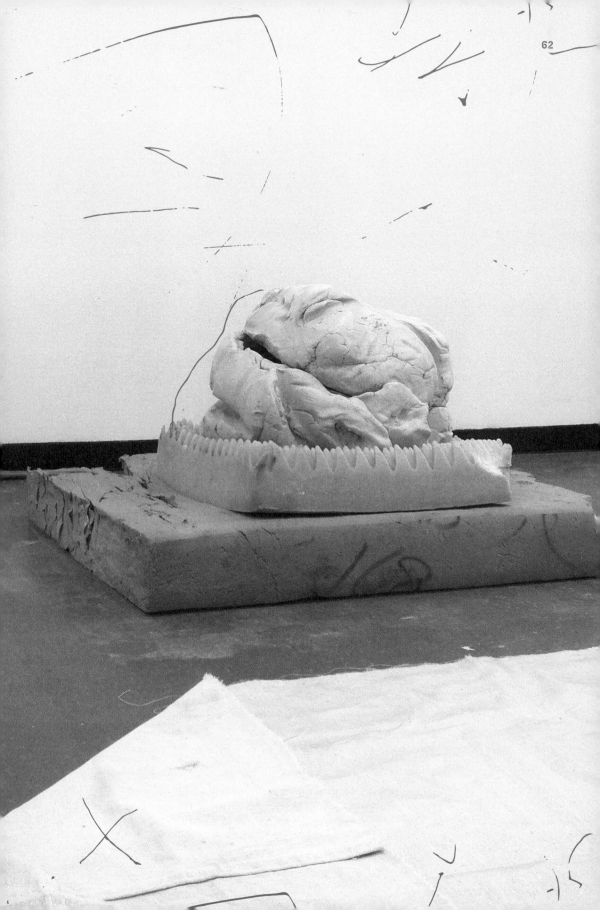

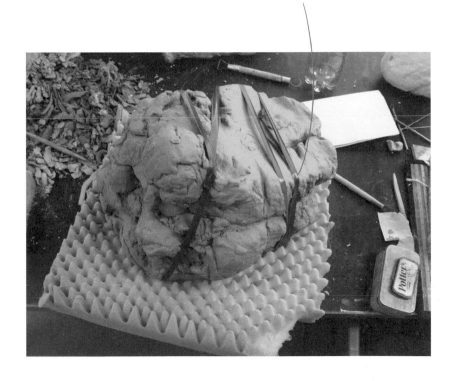

Hollowing out, drying, slow process

Patience and waiting

Clean up, let dry, resting on a piece of foam

Fasten the two parts together with tape to force
them to dry together and sit still so that the clay
does not move too much.

Every time I start and finish
my work, I untie and tie it up

Hollowing out takes a few days

I want the cut to be almost invisible
so that the two shells fit perfectly

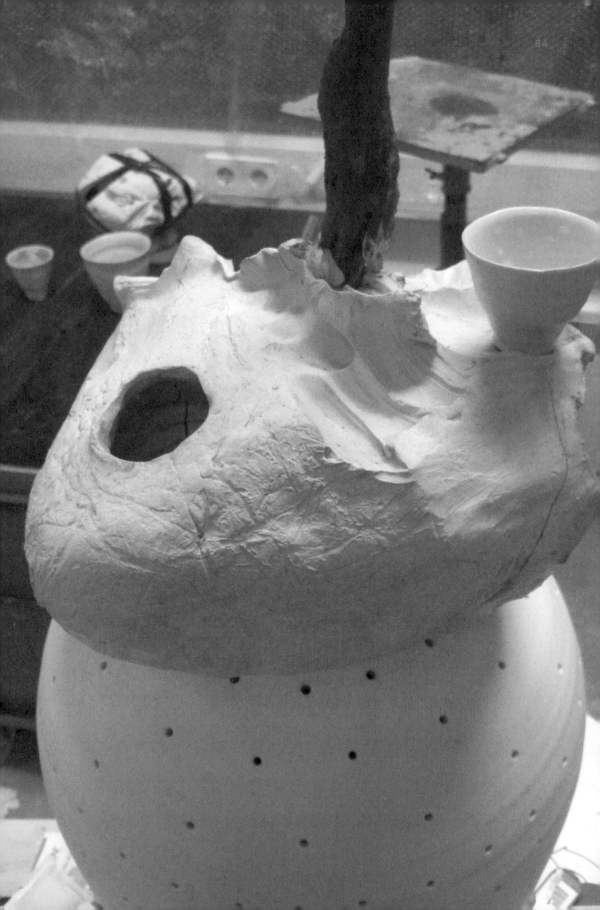

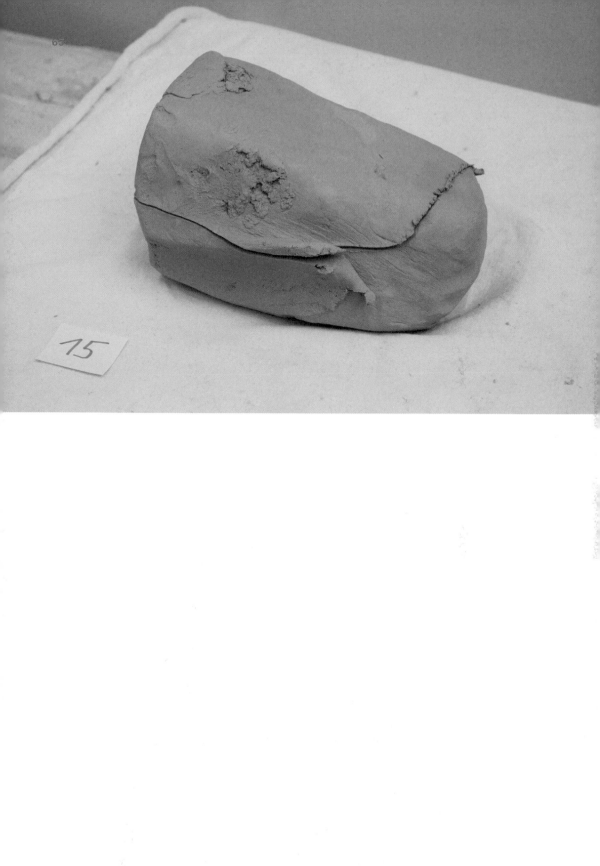

15

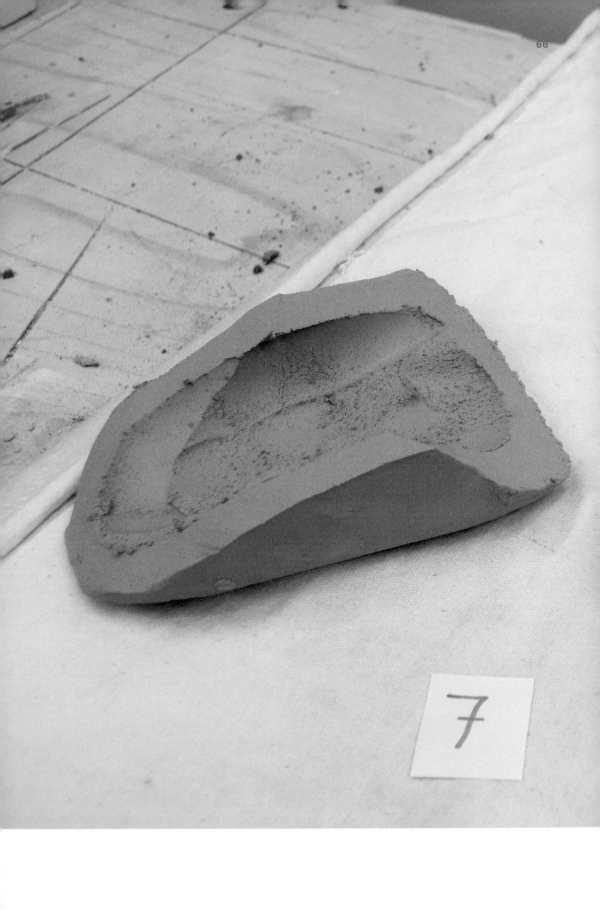

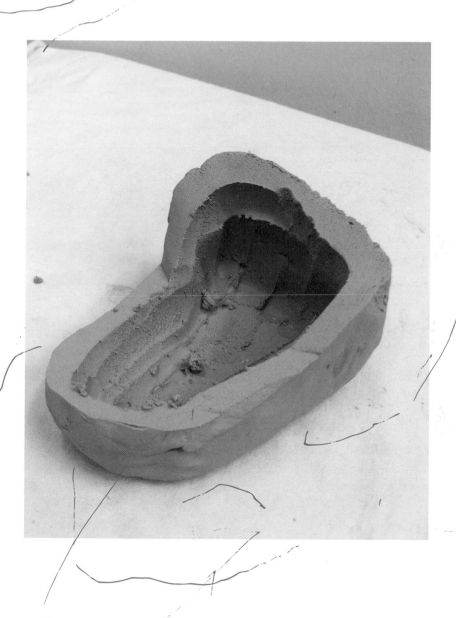

I hollow out the clay for preservation. It is a simple, purely selfish desire to have a pile of clay. I want to preserve this form forever. And to keep the whole shape without a hole. I ideally divide it into two parts, dig out my shape and oversee the whole process as slowly as possible so that the two parts fit together, and so the cutting line is small.

I love the idea of finding a shaped lump of clay that speaks to me with its beauty .

Create a line

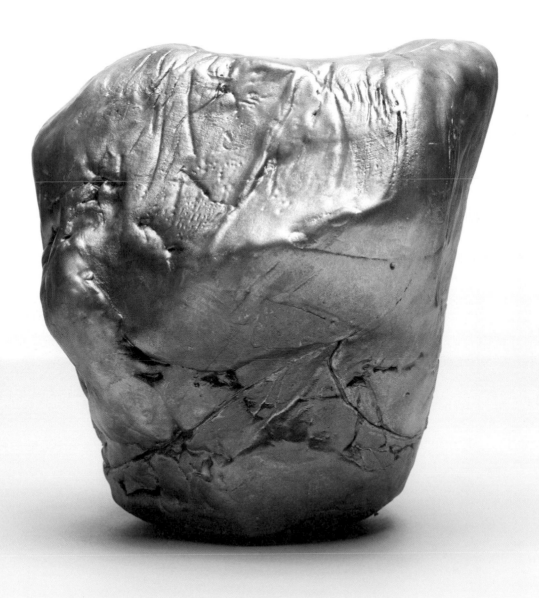

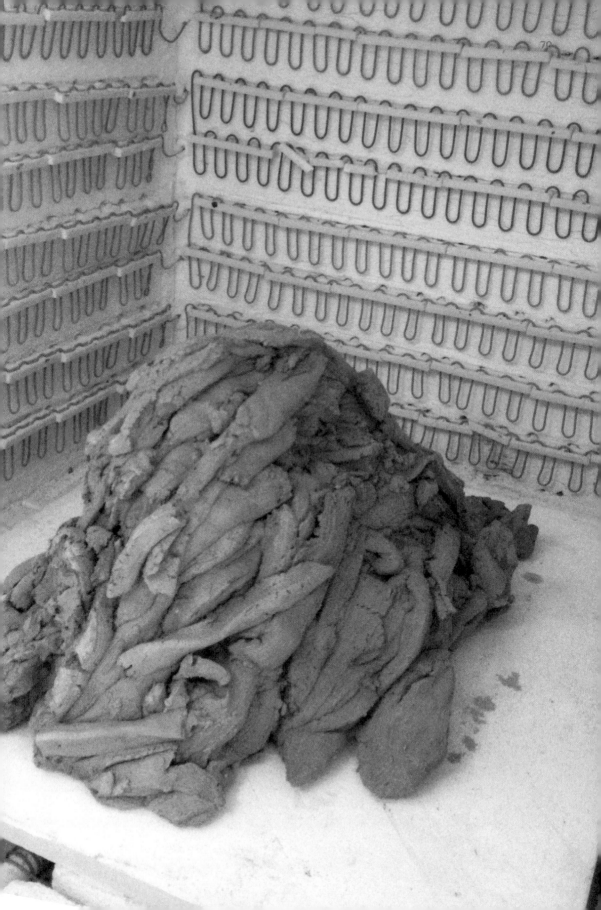

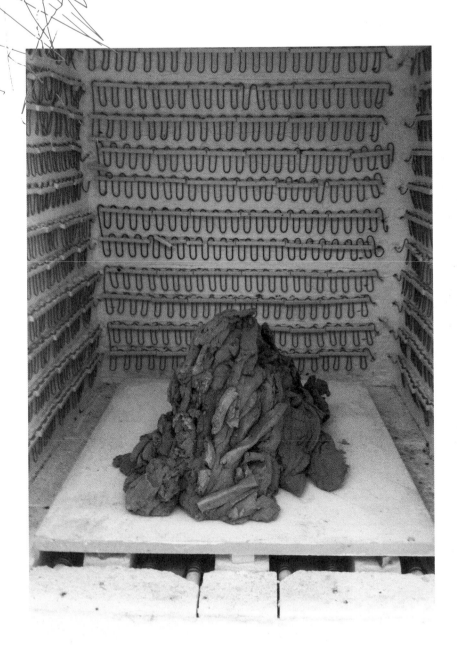

sleeping residues in a ceramic kiln

dries faster in a warm environment.
In the morning it will be ready to burn

Settings

stage

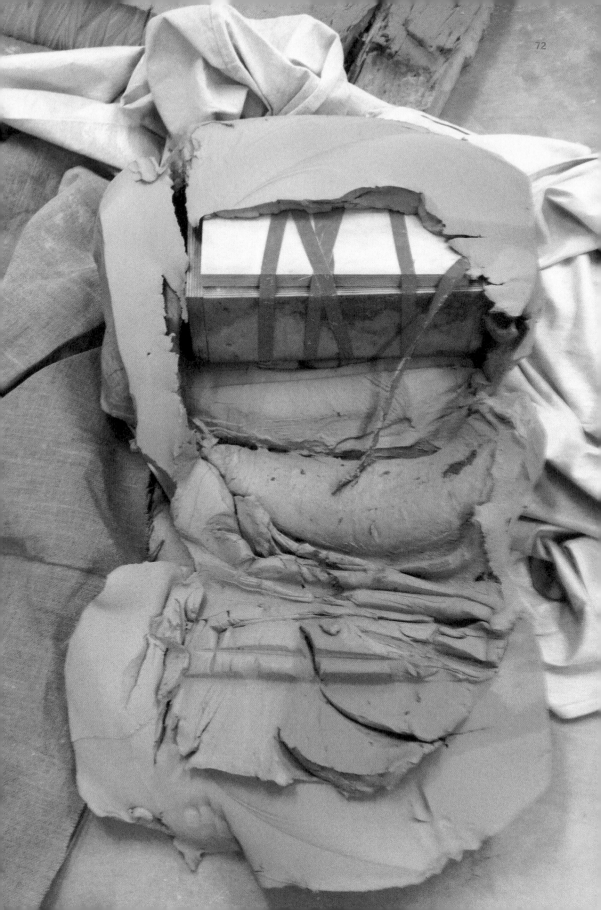

message in a bottle. Uncovered secret

One of my experiments was to increase the volume of a sculpture without having to use large amounts of solid clay. The intention was to cover an empty wooden box with a layer of clay. Large amounts of clay would be too heavy. The purpose is to facilitate handling, shape and form

A wooden box with edges does not stick with clay. This method of producing a large stone technically fails

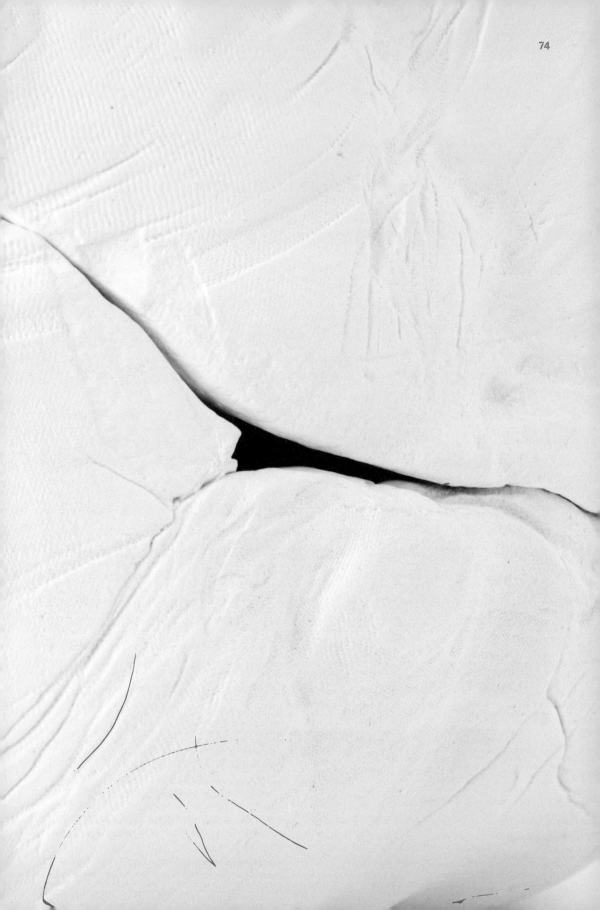

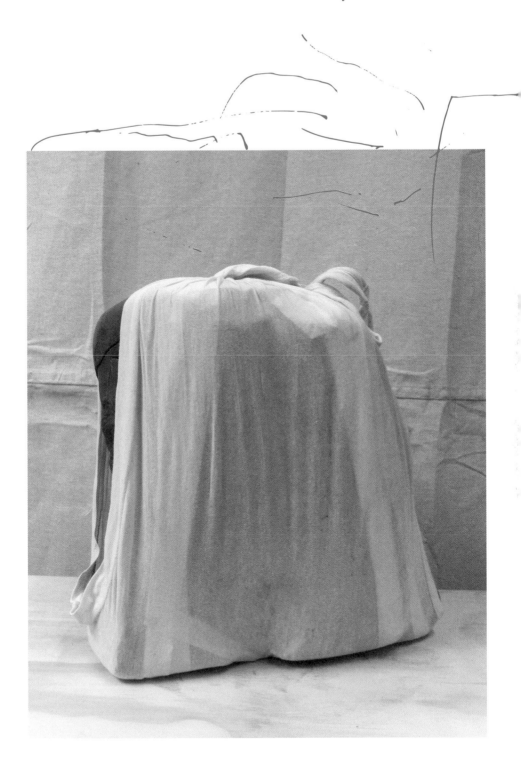

paper tape and T-shirt for drying this brown stone

During the first stages of drying the ceramic clay, most of the water evaporates. The clay body moves slightly and both parts are exposed to the risk of cracking and deformation. To minimize most movements, I pull the two parts together. Every day after digging.

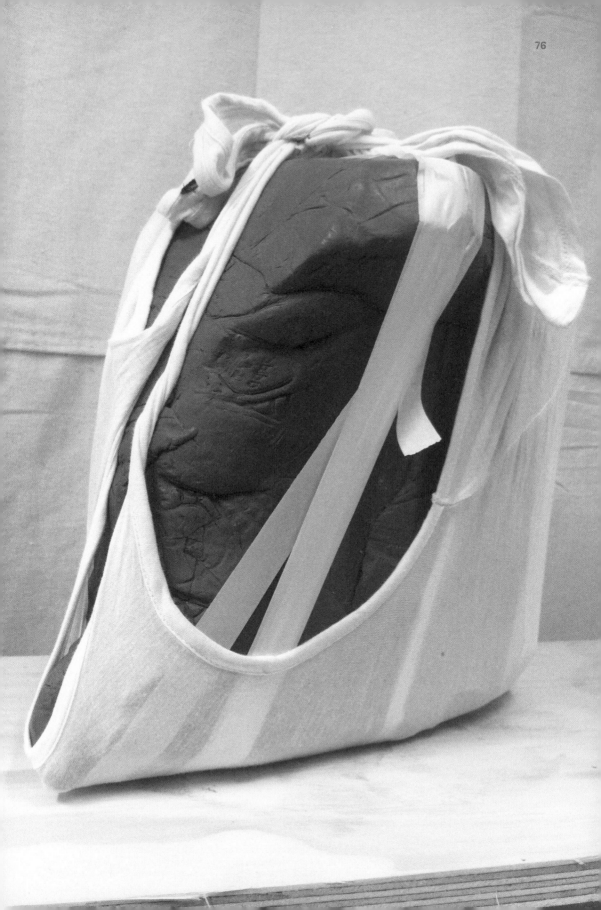

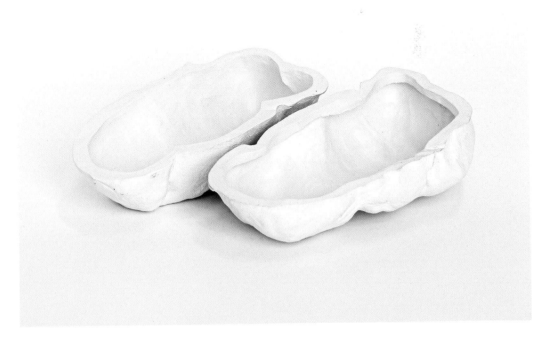

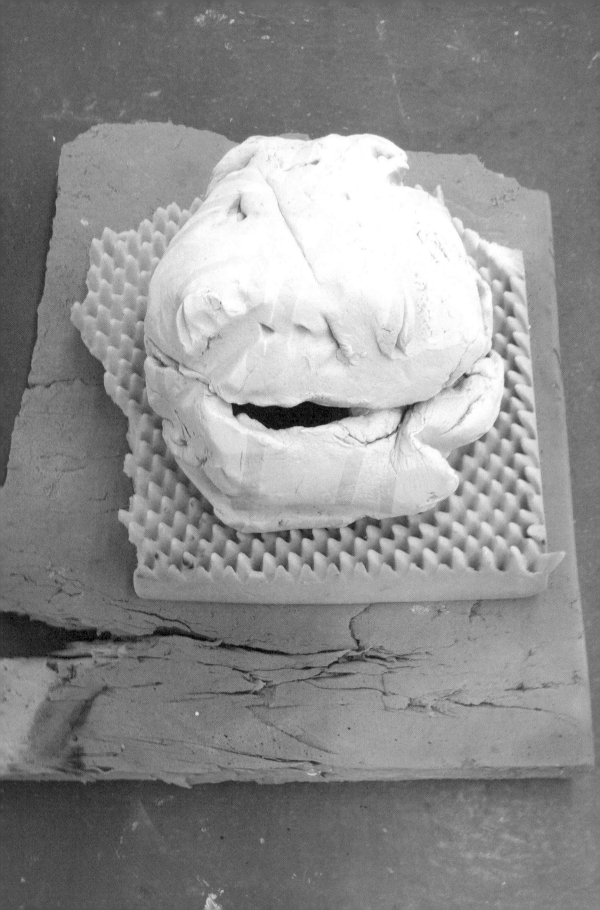

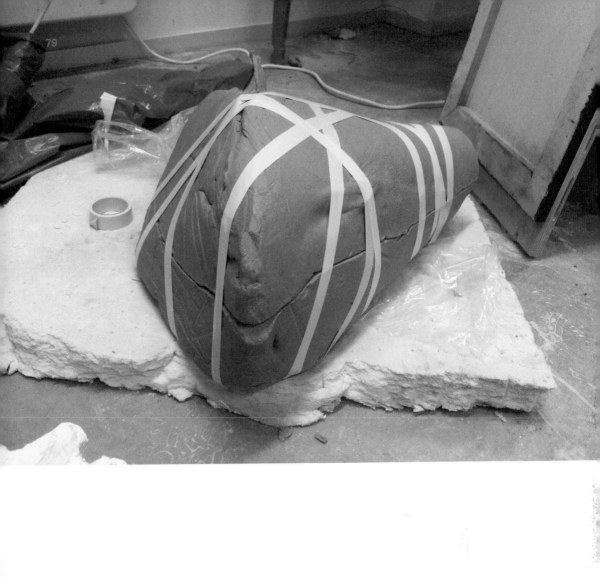

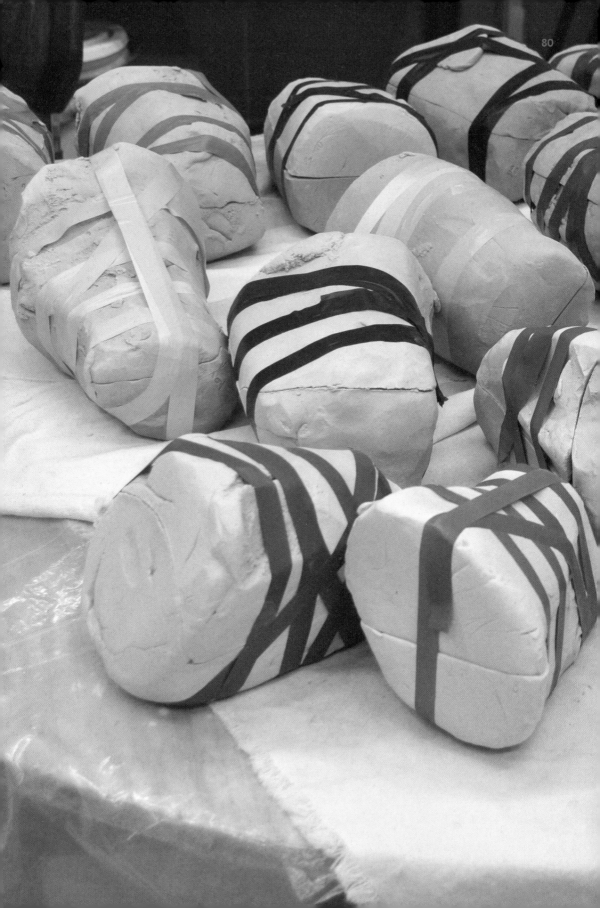

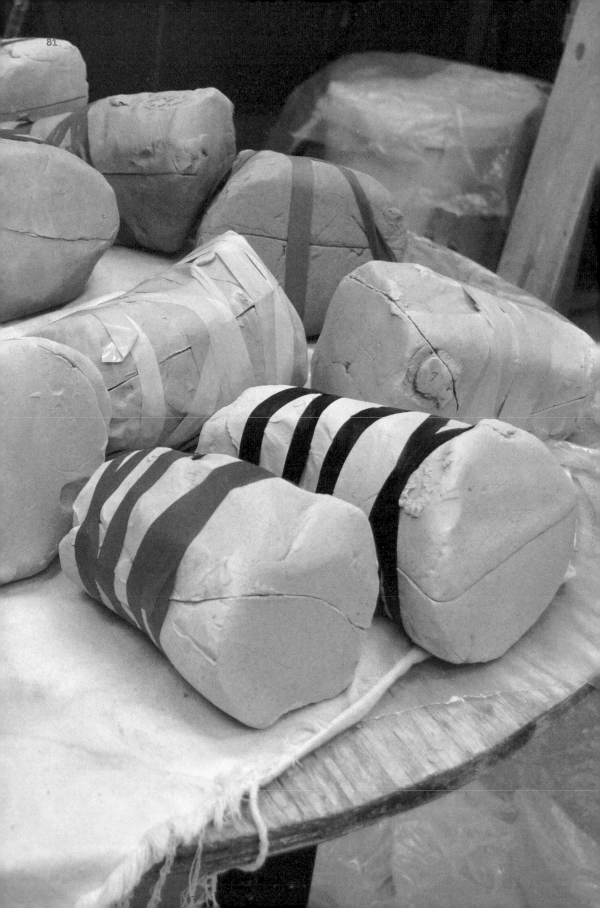

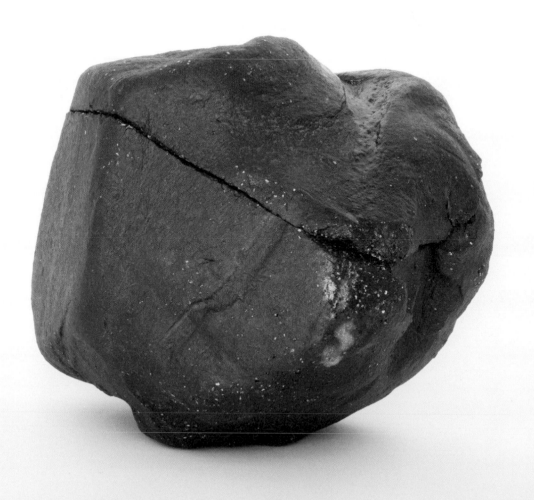

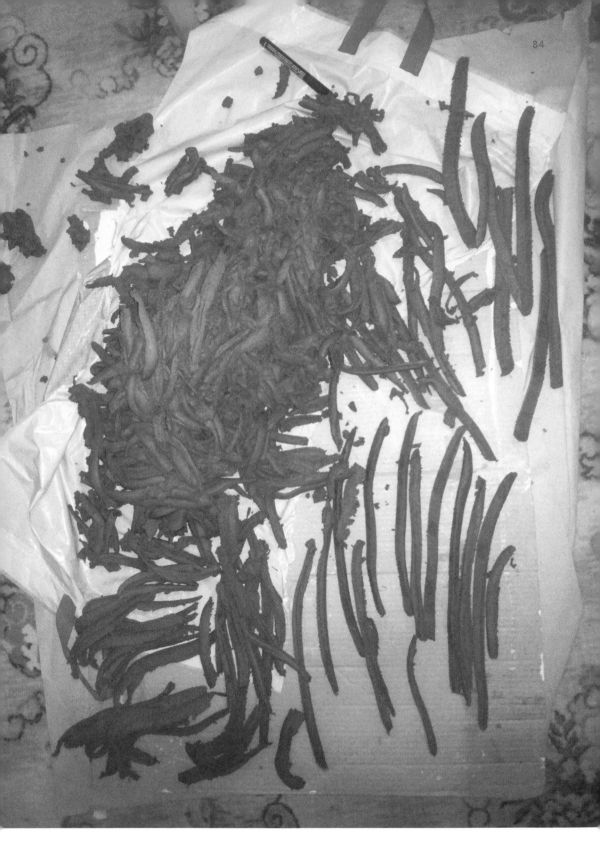

(un) organised clay sticks

Side product

Placed in order

Bounded by paper and plastic

Mess

Randomness in order

The movement of my hand
composed this chaotic still life

Interventions in the home environment

My room served as well as my studio.

The carpet didn't get dirty because
I used a plastic bag to store the interiors.

While digging a large stone,
I sit on the floor of my studio.

I only focus on digging and I want
the shell to be nice and complete.

Automatically performing this movement
for hours becomes a routine.

The right hand performs the same movement again,
cuts, grabs the noodle / stick and places it next to
my body I accumulate interiors side by side

This creates a separate composition

After a while, I look and realise that
I've done something valuable here

that's the perfect piece

I own it, I did it without thinking, I feel pure,
there is no intention in this work

and since a by-product was created that I didn't work
on intentionally, I wouldn't say it's work, it's a notice

after documentation it will be a record and later
the presentation will become a work of art

but now at this moment of realisation,
it's a noticed element, it makes me happy

like branches in the forest — affected
by the instrument and the human hand

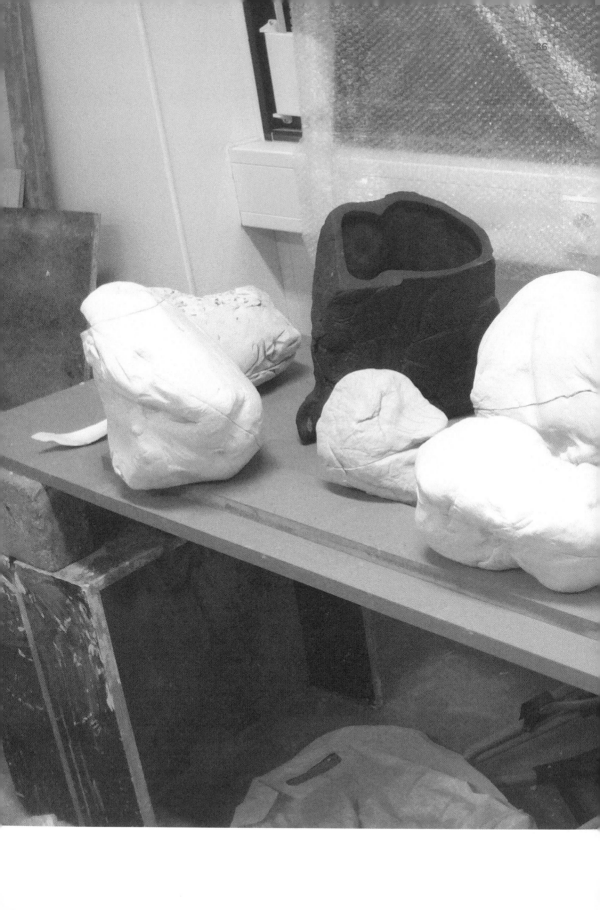

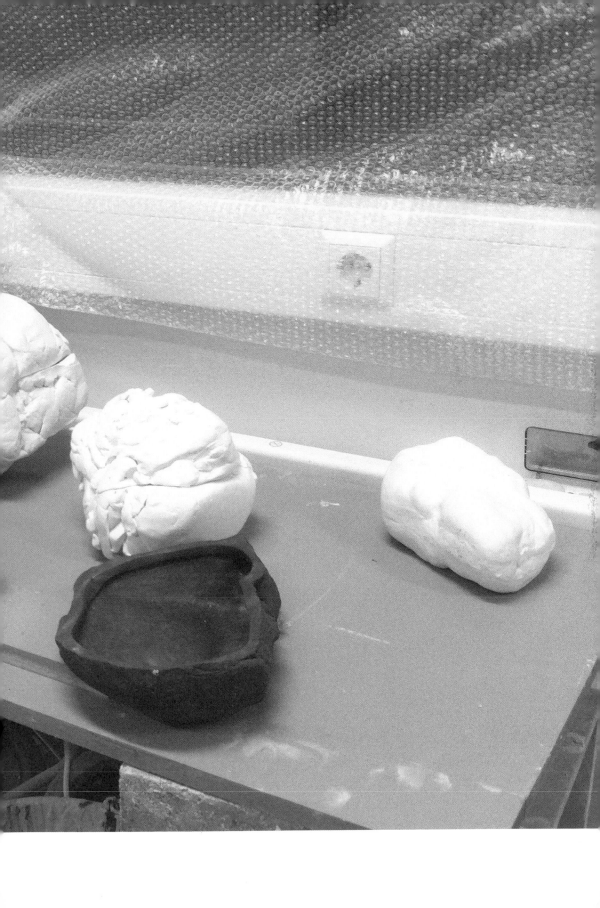

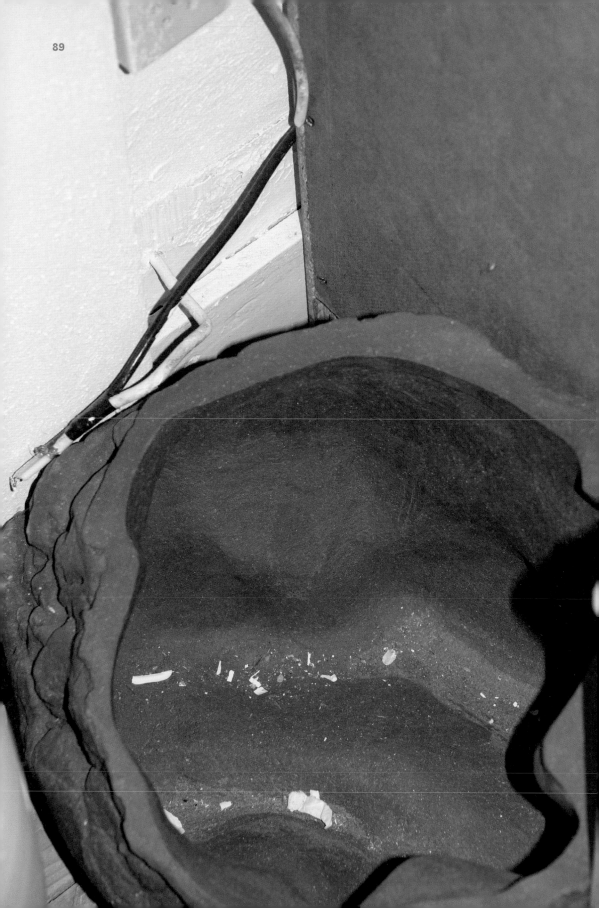

89

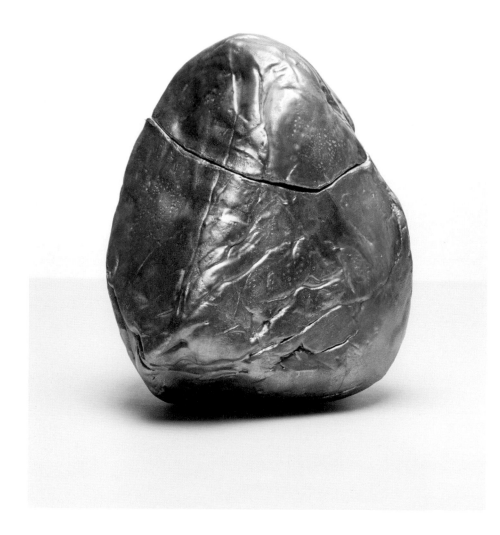

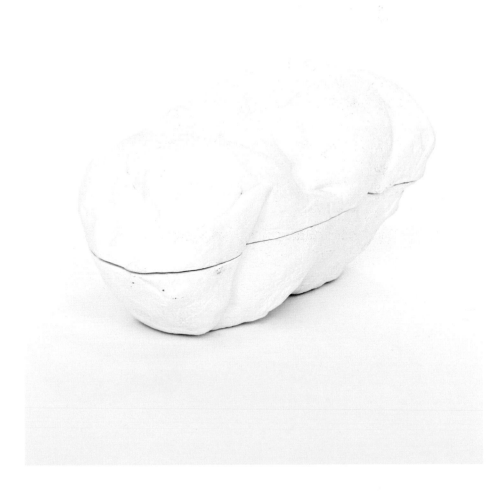

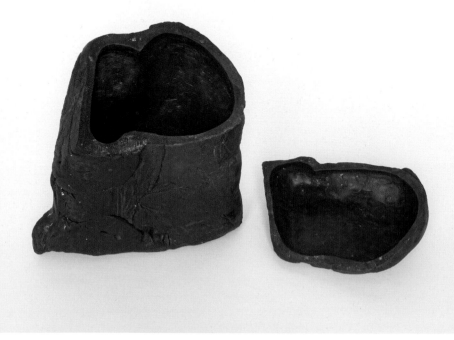

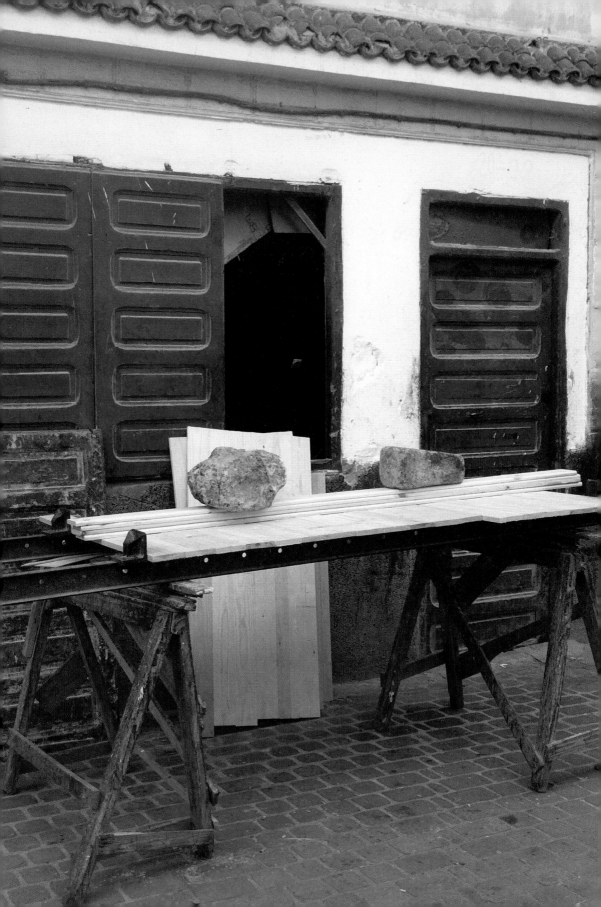

Changing your mind
I can change my mind

In the endless openness, in the flux of changes
and possibilities, I cannot find the thread.

This is a statement.

There is no end. The end of the creative process is
the moment of exposure. There will be even more
moments of exposure. For these moments we need
to find the Presentable. The artwork does not have
to be in a finished phase. If it is Presentable

What are the criteria?

A deadline pushes things into a solid form, one that
is eventually still in flux. Such a kind of state is the
norm here.

As life is a continuous change and stress.
A personality arises, it becomes an existence.

We cannot stay the same. We cannot stop time.

I have been collecting documentation material from the
start of working on the Hollow sculptures. It began —
As a pile of clay and something solid, then it started to
become something else;

By my own touch it turned into
whatever shape and purpose.

It cannot be just a random object if I put it in a gallery
context; if I expose my stone in a gallery it is not just
an object. It has a story behind it, its own history of
becoming to the point of where it is now.

But this I forgot in time, of course. The object
organically developed and this is imprinted in its skin
and its silent memory. Oh, if only stones could talk.
They would have explained themselves, would have
the opportunity, in the gallery, NO

They are what they are, here and now,
with no ability to speak

I am a stone whisperer

The material collected from the process contains
the inside clay ('the insides'), fired as ceramic pieces;
pictures from the hollowing process. Stones are in
different stages and different positions. There are a
series of similar pictures from different angles, various

combinations of setups in the photographs.
There are photos from places where they were
stored, the safe ways of how they were packed.

They are always somewhere somehow.

All sculptures cannot exist in a specific way,
always installed. Preserved, like the sacred items
for the purpose of admiration from the audience

They can be a part of an installation but they
will always have more options to live their lives.

Whatever the circumstance of life,
there are infinitely many different paths.

Their individuality is a secret that can
be titled by me. They have empty space inside.

They can contain but they do not
sustain anything material.

If I present them on a table, the table becomes a part
of the work. The pedestal is not invisible. I cannot
make them alone, floating in the air.

I cannot accept the idea that they will lay on
a pedestal like dead parts of something other,
alone, left.

They need to connect with
the whole space around them.

This cannot be offered now.

This is what can be offered now.

I can offer this now.

I don't want to offer anything.

The offer should come to me.

The inside is smooth and is never visible. It is common
sense, like a myth. It does not have good PR. It is very
static and no one will be surprised because it is not
about the surprise. It must stay a secret.
A well-known secret.

Secret that no one will ever discover.

Well known for its reputation.

It is the rawness in provoking the minds of bored
people. The curious ones will suffer. They will remain
without explanation.

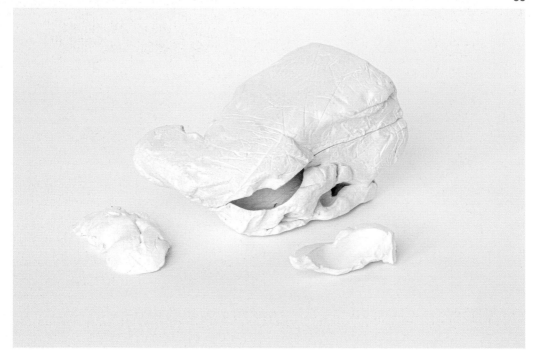

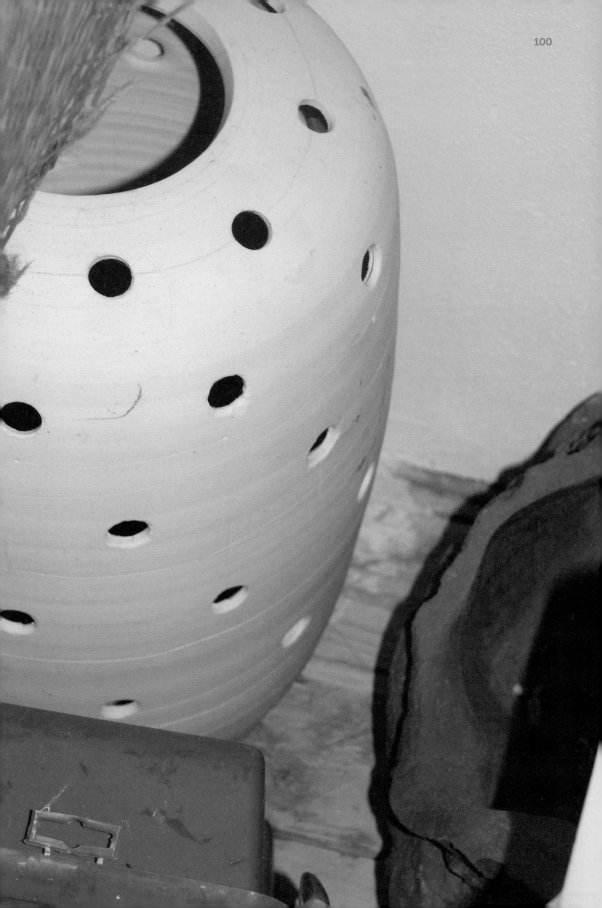

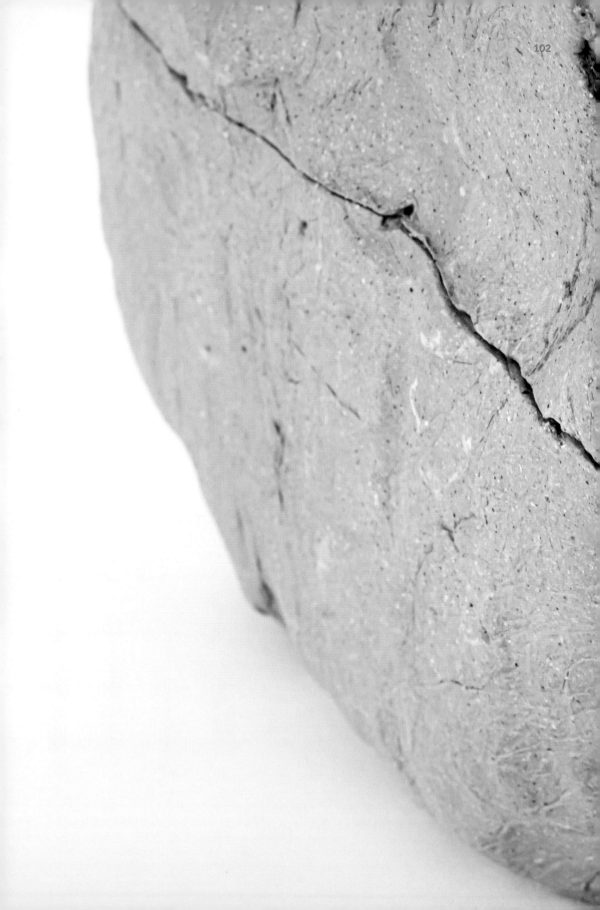

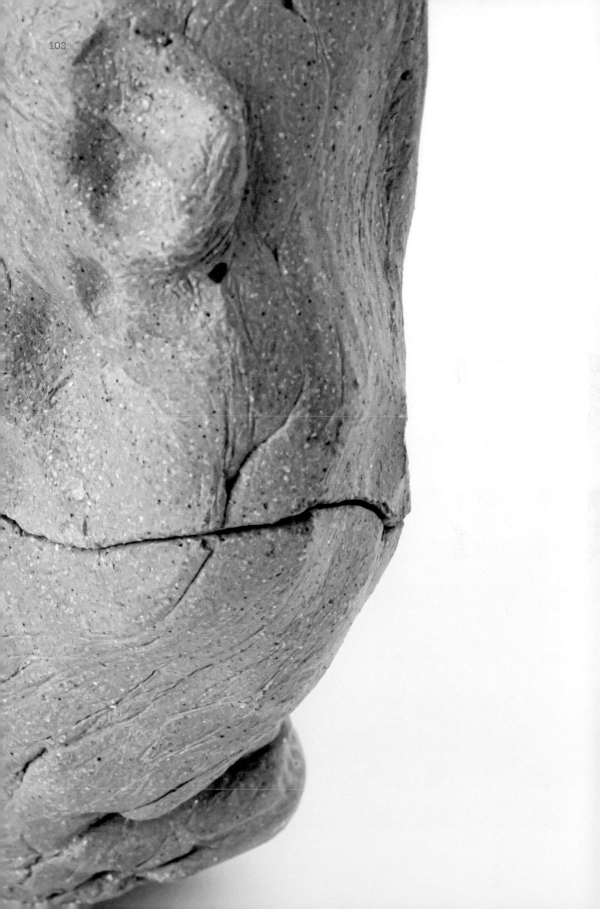

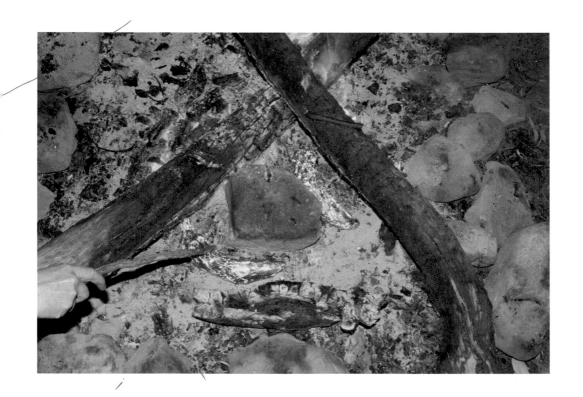

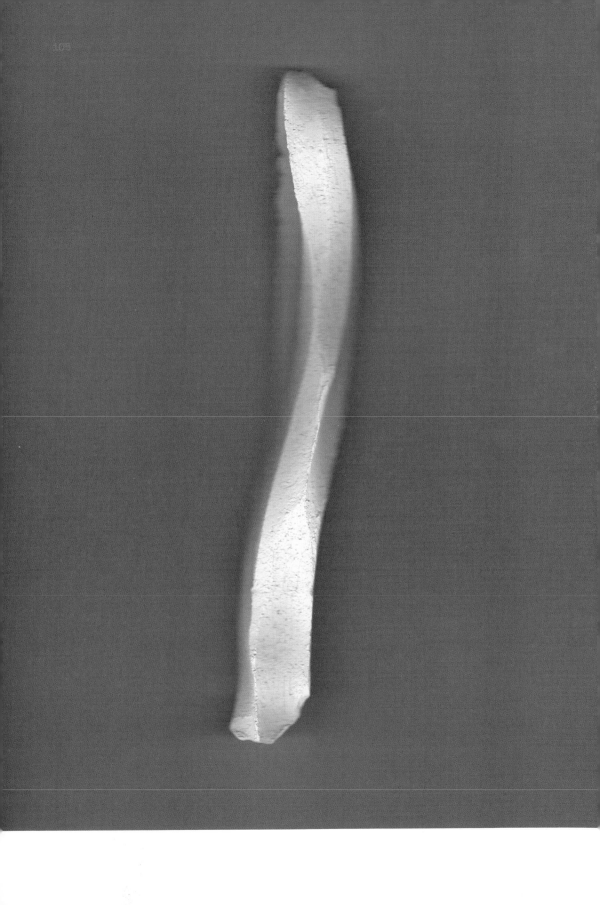

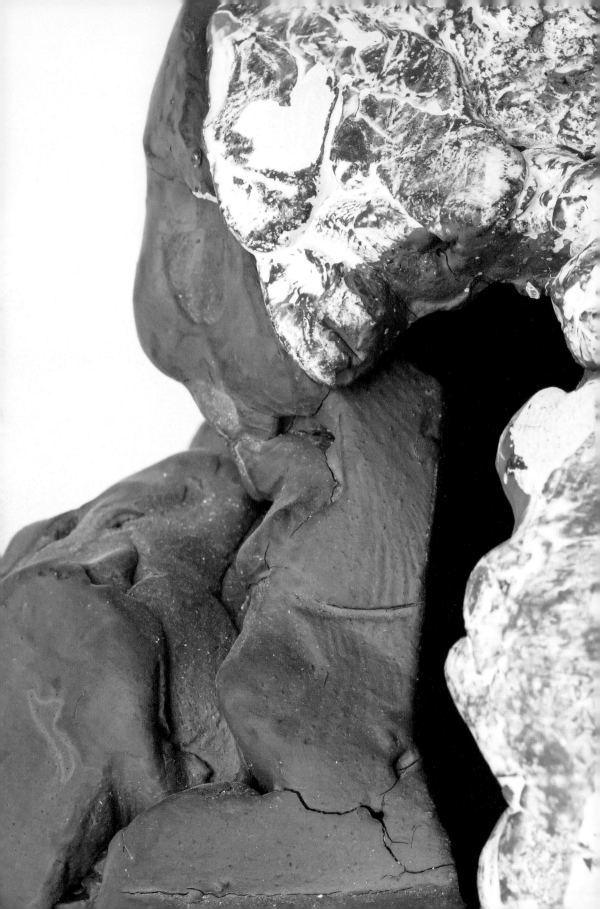

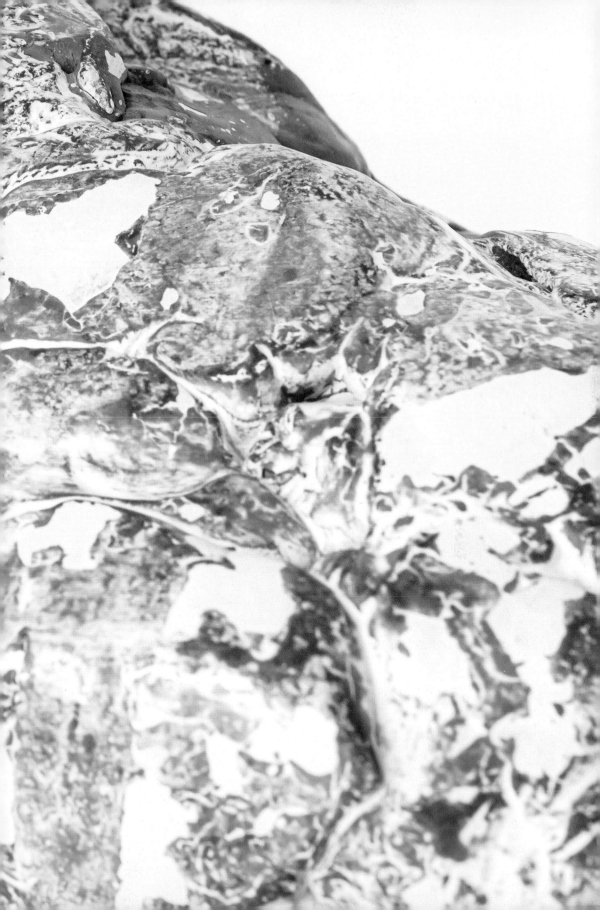

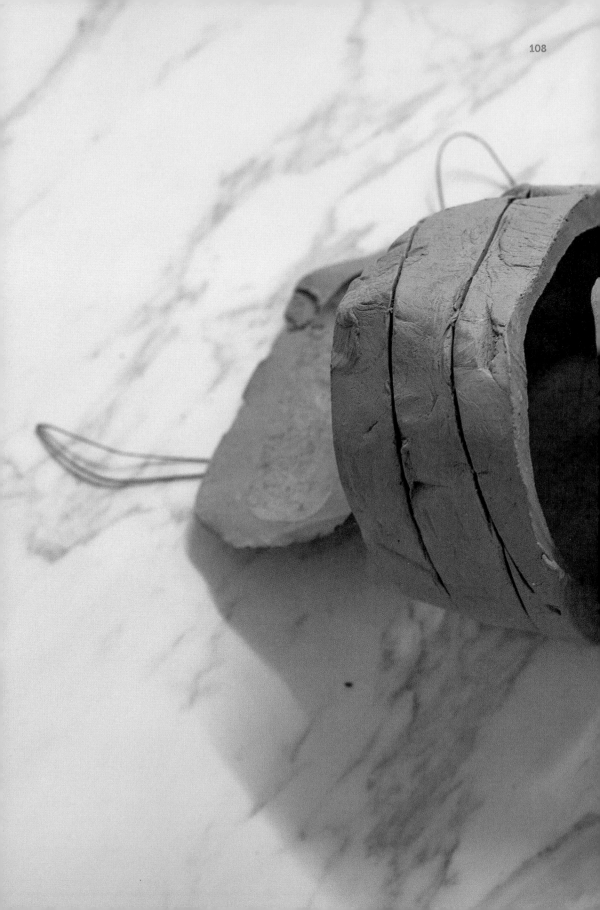

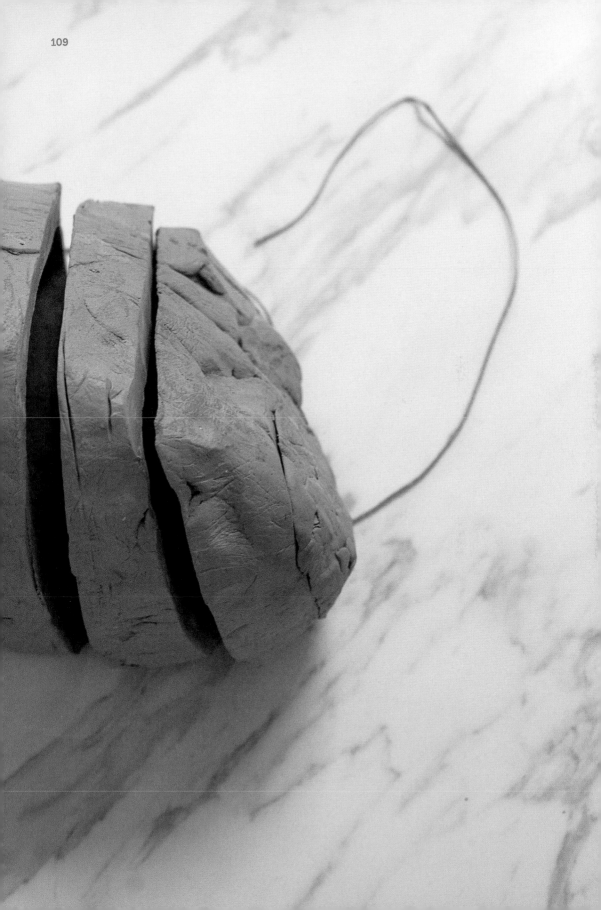

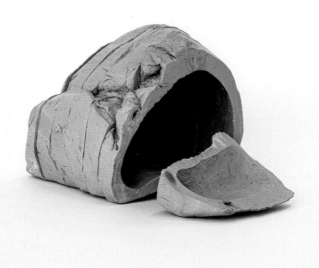

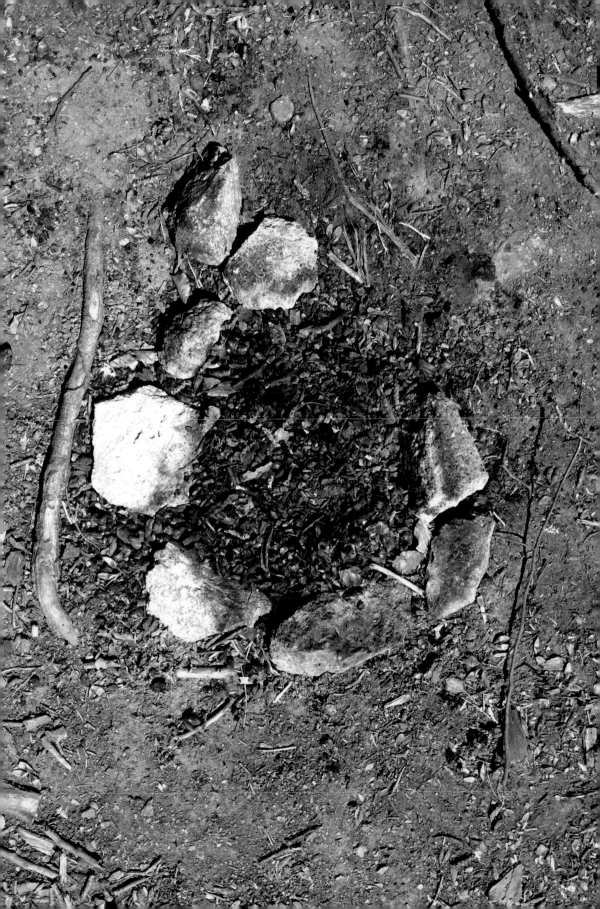

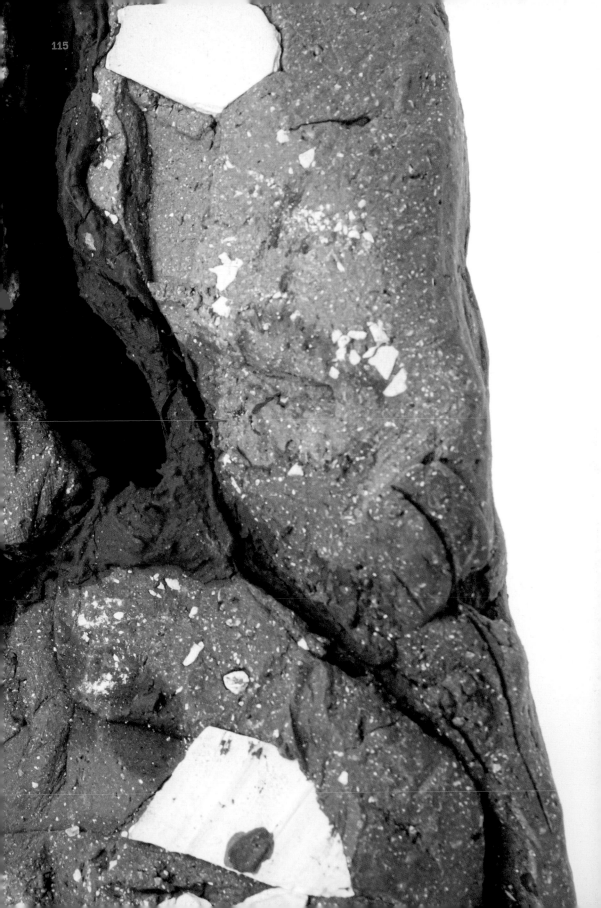

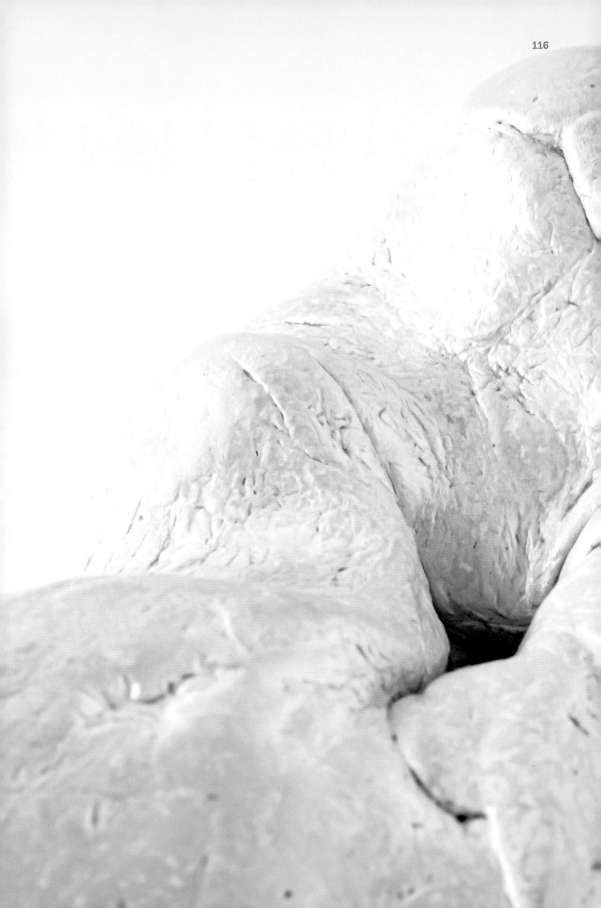

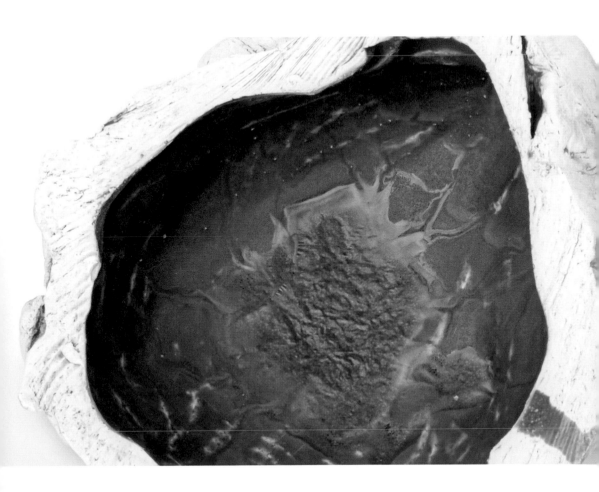

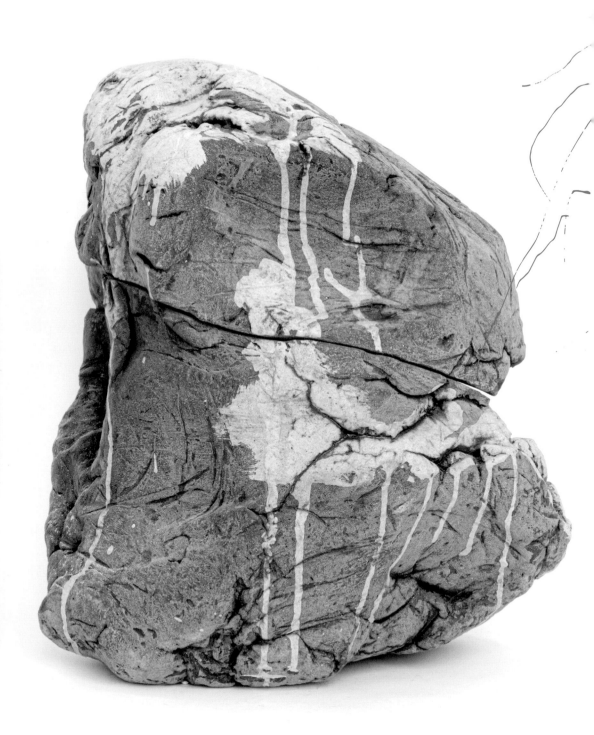

(based on the essay "Circulating Reference: Sampling the Soil in the Amazon Rainforest" by Bruno Latour)

Denisa Kollarová

It is a field trip she takes every time these objects speak to her.

I will attempt to describe my observations of this journey, where she carries these objects, from her world into a new destination. I once followed her steps without the effort to actively document her actions, to instead try to experience them. She knew of my presence and mostly ignored it. If my memories could be visualized, they would serve as perfect evidence for her journey. Instead, only a few documents, coincidental photographs to be precise, exist that can prove my words.

A picture can be worthy of a performance, but that depends on one's relationship to documentation. A picture can also be a carrier of fictional information.

Her job consists of taking care of the objects. She carries them around carefully wrapped in bubbles, silk textiles or sketch papers, packed in clean, neat, grey boxes. The number of boxes that she takes with her on each journey is determined by her means of transportation, which in turn determines the size of the luggage she is able to carry along. This luggage she holds is lighter than the world she comes from but heavier than the paper on which my own documentation of this journey will be printed. During this carriage-ride something is preserved whilst other things are lost. What she loses in a matter of reduction when preparing for her journey, she will gain in the process of tracing, documenting and archiving. The more she distances herself from the location of origin of these objects, the more she gains in a new sense of how to arrange them in relation to their new site.

When she arrives at the destination, she creates a demarcation — a natural edge of her field of installation. This demarcation is defined by the redistribution of the boxes in the actual landscape. While placing the boxes she scans the environment and collects new artefacts that capture her attention. The boxes in which she transports the objects, as well as the manner in which they are packed belongs to the world of "things", but as she starts unpacking these objects in a new location and installs them with all the collected artefacts and materials surrounding them, they start to belong to the world of "signs". She unpacks these objects and installs them in their new locations.

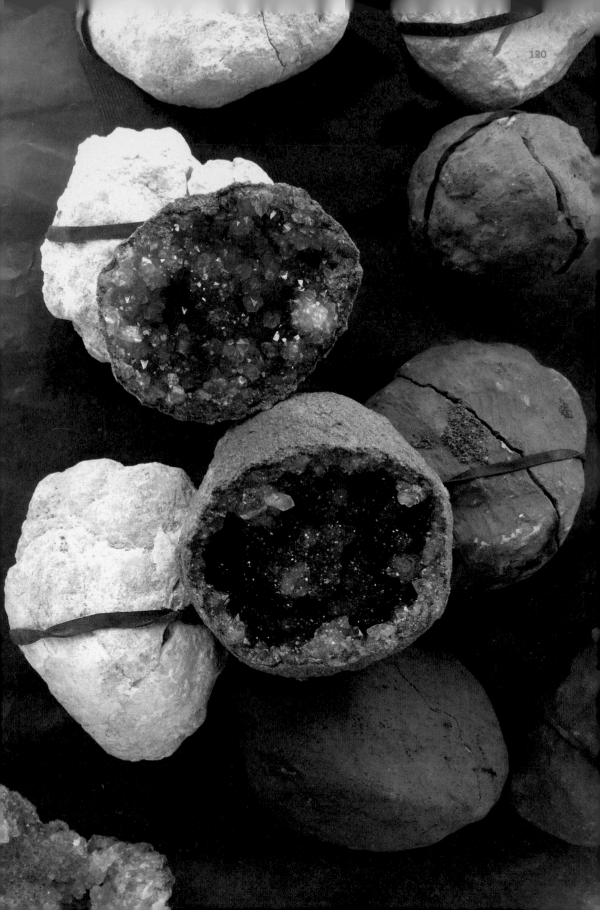

In this way, she creates a natural settlement of objects that she carried with her and the things she has acquired from her new surroundings. Earth becomes a map, a map becomes a destination, a destination becomes a concept, and a concept becomes documentation. She doesn't talk about the world she comes from, rather she constructs representations of it through the very arrangement of these objects.

Yet we are still neither really far nor close to her world.

As she places them around, she speaks of these objects as if they are members of her family. She knows them intimately; she feels their character and she relates to their changing needs. Her way of knowing them does not reflect a real, external world, but rather a real, interior world. Scattered through time and space, these things would have never met without her arranging them into such relations. She takes her time looking at them and speaking to them. Her voice is very gentle, I cannot hear their conversation. What I observe is how she reassembles, reunites, and redistributes them according to entirely new principles made dependent on her mood. Once in a while, she holds the object for too long and that affects the shape of its matter. She is permaforming. The object is transforming.

After she installs the last object that she carried into this destination, she grounds herself in this new environment. She returns to her roots, she starts changing her colors and begins vanishing into a sea of greens, greys and sepias. I hear her whispering voice attempting to identify these colors but in some places she fails to match the shades with the objects. Her rose shades become wenge, her yellows transform to smaragdines and her blue parts turn glaucous. In some parts of her body, her smooth skin surface turns as rough as the object located in close proximity to her. The texture of her skin is slowly morphing. This is the only time when her voice speaks to me directly. She instructs me with a reference number for each swatch in her CMYK color model, in order to communicate how to archive it and flatten it into photo print form for documentation.

Back at my home, I flip through these coincidental photographs, retracing my steps back down the roads she has traveled. I focus on the pictures, their colors that lay in a hollow of my hand. *

Permaforming
Denisa Kollarova

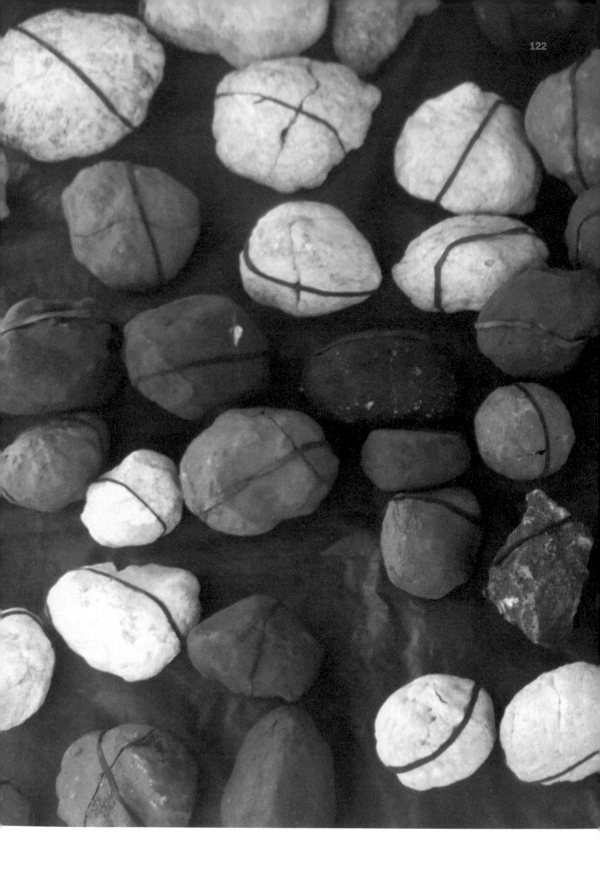

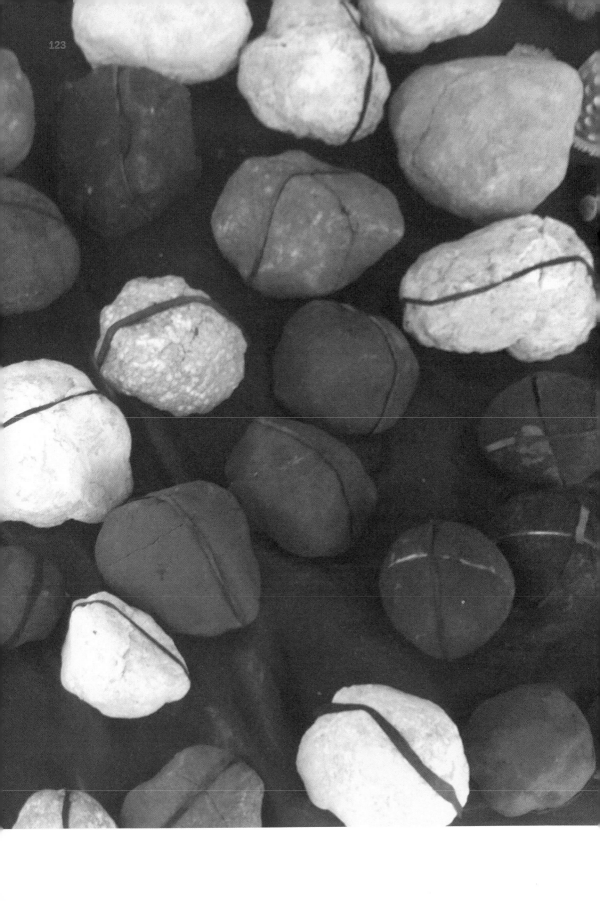

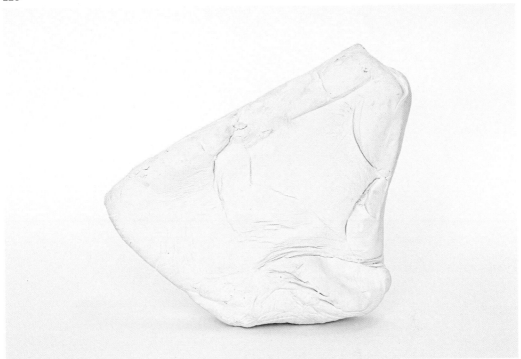

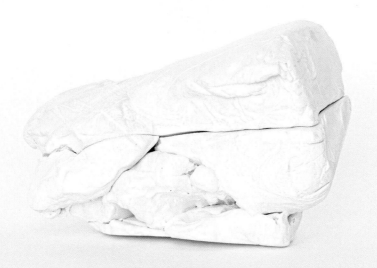

Obr. 8.

When pruning trees, cuts are made with regard to the life and future of the trees. The motif can also be selfish, there are interesting theories and knowledge that determine the time of year and the parts of each tree species to be removed. I love that there is so much care and philosophy behind the trimming practice. The Trimming Master also uses his intuition.

These branches look like the inside of my stones.

An assembly of sticks, collected or just collected in some (dis) order. You can feel a human touch over something bigger.

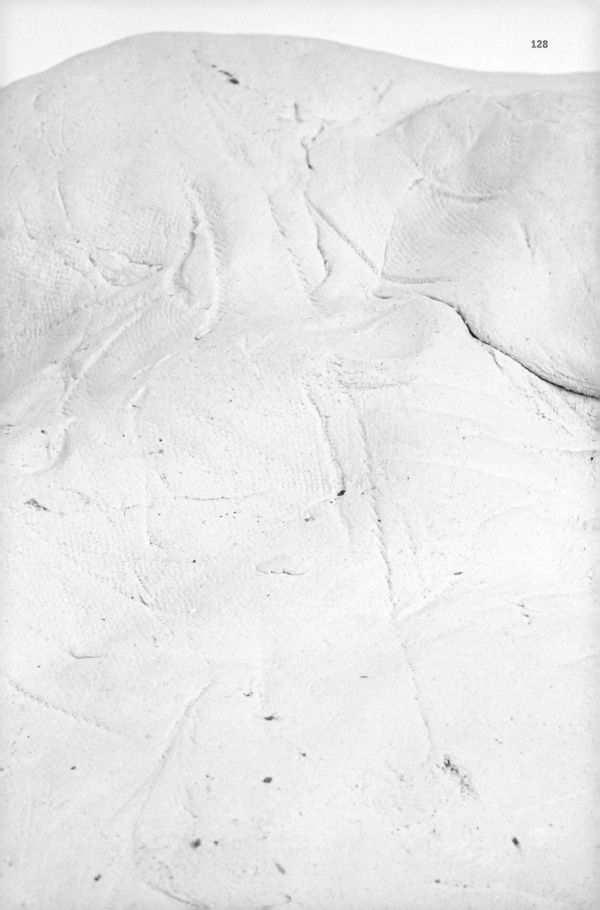

At the end of Watchmen, Dr. Manhattan tells Adrian Veidt "In the end? Nothing ends, Adrian. Nothing ever ends."

Pedro Moraes

You open your eyes and you find yourself in a room, a room that is located somewhere. The room is in a street, in a city, facing the sun from some direction, east west north or south. The room has a certain infrastructure that accompanies it, adjacent floors, whatever is above and whatever is below. In the room you find objects of all shapes and forms. All of these objects were already there when you opened your eyes for the first time. Whoever made them abandoned them. They seem as if they have been made just a second ago. From time to time, if you squint and pay close attention you can see an object coming into being, its parts slowly converging to a single point in space, moving closer and closer together until they are all at the same point. Suddenly an intense flash of light, a thundering roar, and a new object is ready — well sort of, objects are only ready when they cease to exist, and in a certain way they were always already in the room.

From the objects that are already in the room when you open your eyes for the first time, there isn't really any information about where they came from. It's likely that they have been there for a very long time — at the very least, longer than you. From every new thing that comes into being whilst you are in the room, it allows for you to reverse engineer the things that were already in the room when you arrived. Through an intense observation of the present, you slowly make sense of the past. There are many gaps in your knowledge about the room you find yourself in, but it doesn't matter, because tomorrow you will open your eyes again, and you will be in the same room.

The task of constructing a mental model of the world is implied in any and all of our interactions with our environments. On the one hand this model appears as a map that encodes certain salient features of the environment including the position of our bodies relative to it, on the other hand, it is a conceptual model that constructs, at the very least, a plausible chain of relations between ourselves and our environments. In other words, the way in which we understand that root, trunk, branch, leaf and seed are all different parts of the same object we encounter in the world and through such sensory data we transpose to these internal models.

Our preconceived notions of the apparatus that legitimizes an art exhibition are dependent but oblivious to the features

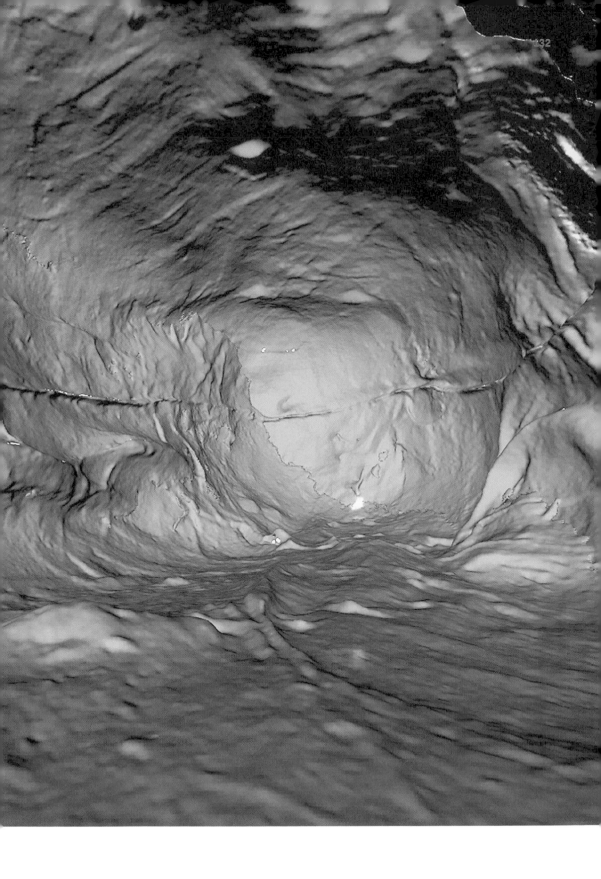

which give any space its identity. An active question that one must ask pertaining to the presentation of artworks is: "How to be able to deploy the context needed to parse an artwork?". Asking this question reinforces that one must provide just enough information to enable a productive dialogue between the work and its context. These are related because they are both necessary, as one is not able to make sense of objects without a particular idea of how they are to be looked at, which, when it does happen, can be exhausting and frustrating. Often, clues can be found on the outer spatial features of a space that provides just enough for an object to be read visually.

We can understand this through two perspectives, one is the idea of emergent properties in the context of complexity science, that complex systems are more than merely the sum of their parts. That is, they exhibit behaviour that emerges from the relations between their components, but that are not localized in any of the components. Emergence is one of the most important attributes in defining a particular system as complex rather than just complicated. This defining feature sets it apart from the systems described by Newtonian physics, which could be interpreted as being defined by the sum of the interactions of their parts. Complexity science suggests that many systems can only be understood as systems, rather than as large agglomerations of parts. Gravitational bodies, large collections of gases or liquids and perhaps human crowds, financial markets, cellular automata and neural networks, all can be thought of as displaying emergent properties.

The other perspective can be identified through the work of Jane Jacobs. Although there are very different characterizations of what emergence might be and the extent of its breadth and depth, in the work of Jane Jacobs, especially The Death and Life in the American Cities (1961), she makes a case for how cities gain a certain liveliness out of mixed used neighborhoods without strict zoning as opposed to the american suburbia model, or as she so eloquently frames it:

Under the seeming disorder of the old city, wherever the old city is working successfully, is a marvelous order for maintaining the safety of the streets and the freedom of the city. It is a complex order. Its essence is the intricacy of sidewalk use, bringing with it a constant succession of eyes. This order is all composed of movement and change, and

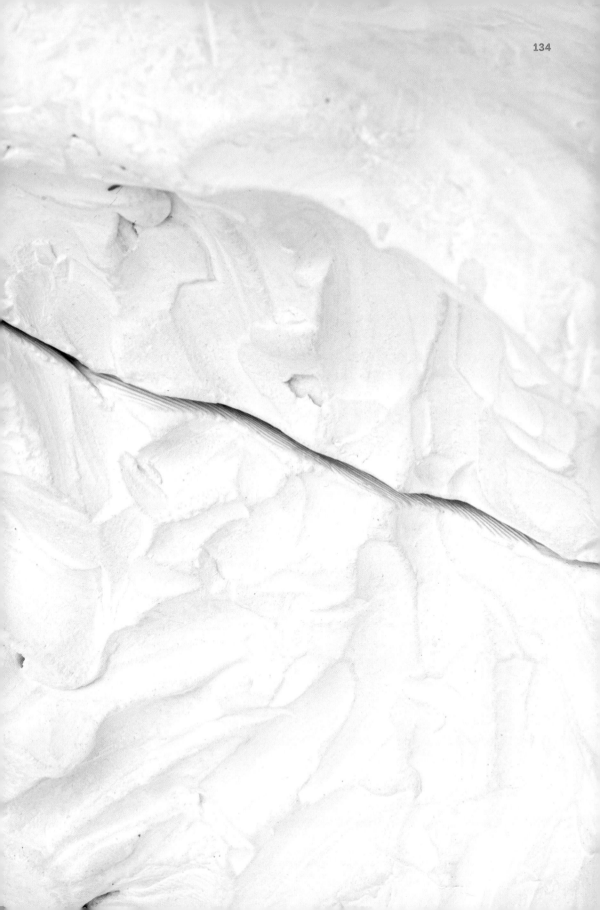

although it is life, not art, we may fancifully call it the art form of the city and liken it to the dance — not to a simple-minded precision dance with everyone kicking up at the same time, twirling in unison and bowing off en masse, but to an intricate ballet in which the individual dancers and ensembles all have distinctive parts which miraculously reinforce each other and compose an orderly whole. The ballet of the good city sidewalk never repeats itself from place to place, and in any one place is always replete with new improvisations.

Both cases depict — though with very different ranges of concern — the necessity of context in the possibility of increasing informational density. This highlights what is necessary rather than contingent for the apprehension of certain objects, that they possess enough context to be understood as part of a broader genus, a kind of family of things that arise from a particular context. For some this needs to be carefully constructed so that it does not fall apart after three days. For others, and this is the class of things and objects that concerns us here, there are objects that provide a context themselves, the difference is explicit rather than implicit, they proliferate and morph, falling to the ground and unfolding, complicit with anonymous materials, letting it be known that the ways in which we provide them with a clear taxonomy, an object, a thing, is incompatible with the evolutionary process that they are but the latest time-slice of.

A friend living in Greece once told me that the ancient stoics would only use verbs to denote continuous processes. Instead of saying that a tree is green, they would say that the tree greens. I wonder how much of our understanding of the world is built around a scaffold of fixity when, for our own sake and for a better integration of ourselves within our environment, we would be better off to think of them as a dynamic flow...

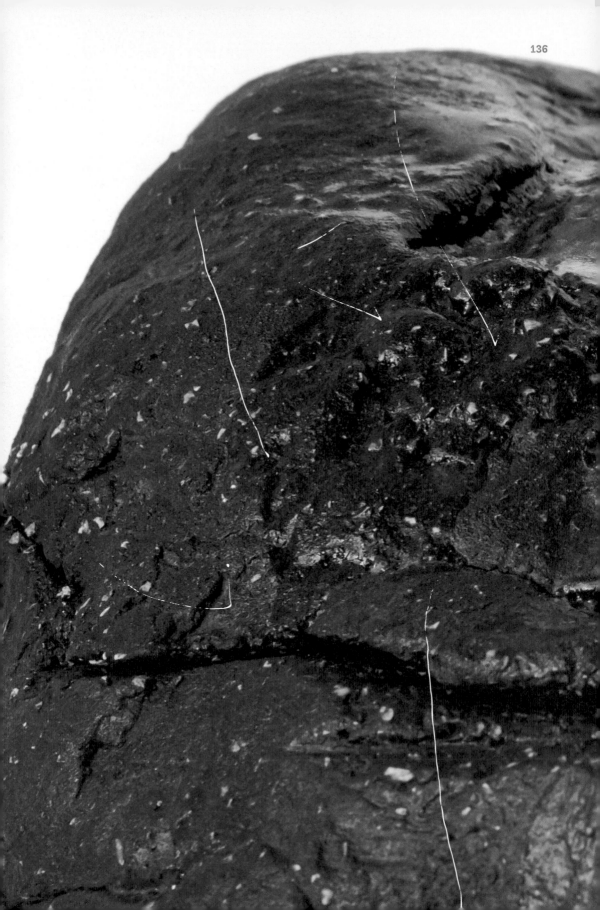

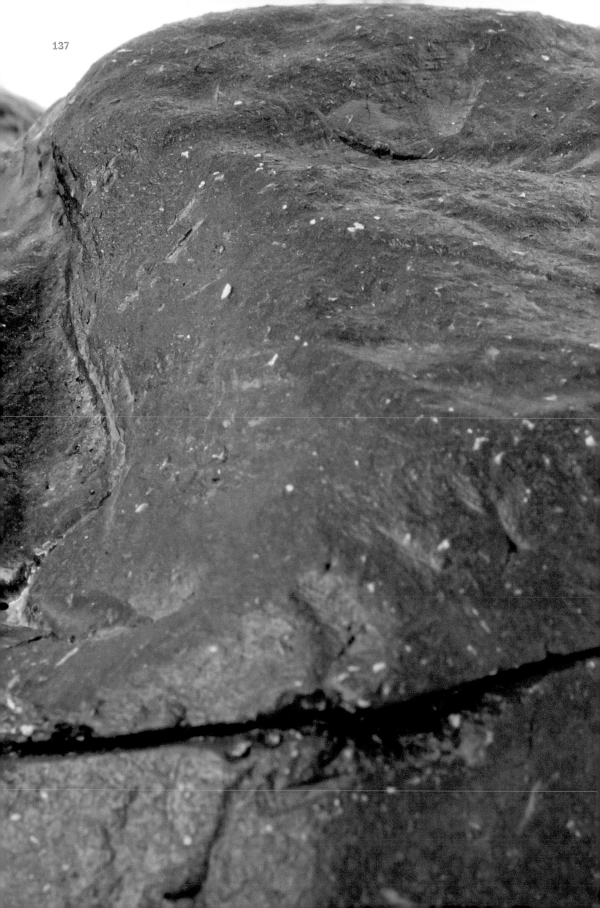

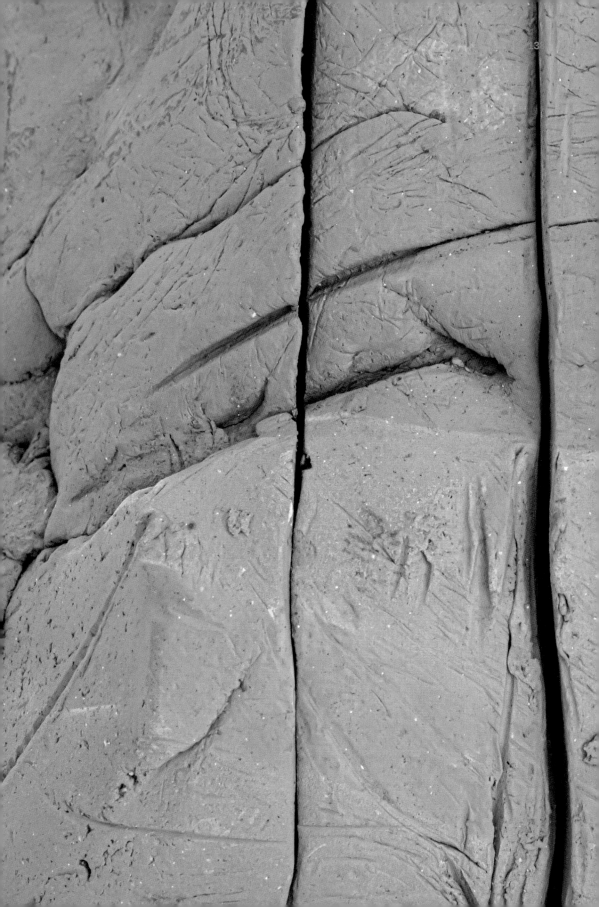

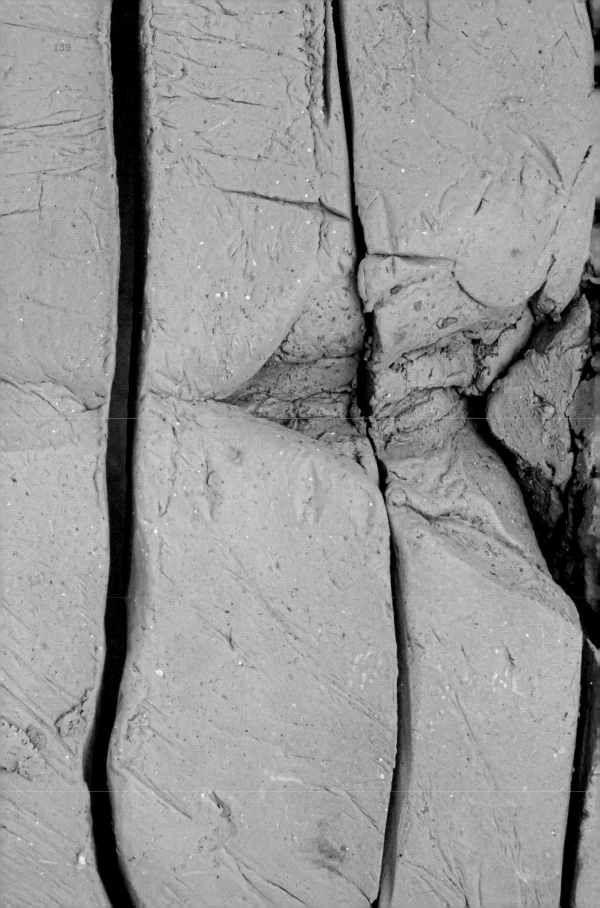

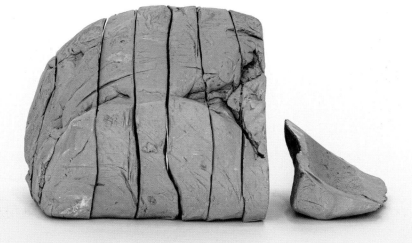

141

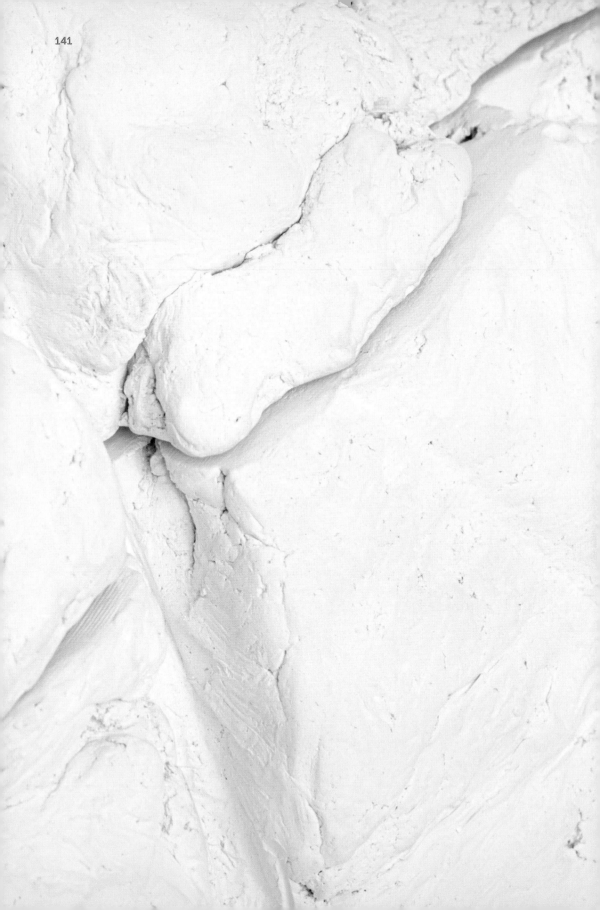

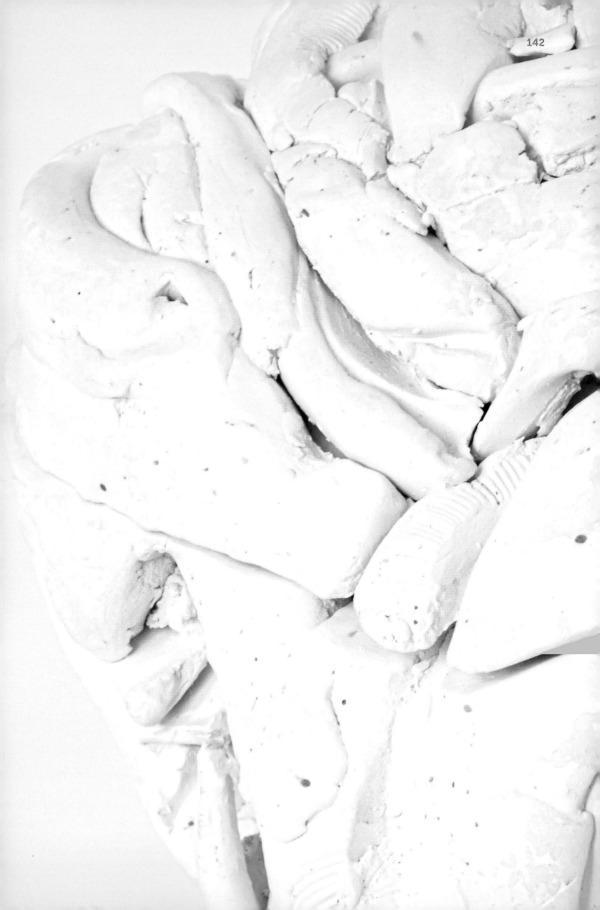

The corn'sant clay
Année Grøtten Viken

IS*

02.00 Dreaming. Corralled by night and the ephemeral soft fragments of thought, hiding behind closed eyelids immersed in the sensitive moment of passing phosphenes while caressing the fleeting touch that no-one can buy or take away.

03.00 The flute calls for the living water to penetrate the scarce landscape and move its soft body, its soma, through the porous mass with the whisper of the wind setting it in motion from behind.

05.00 I roll over. Poke your side and make a dimple. Good Morning, Mr. Echo. I look at the rounded, crooked but beautiful dimple I just made in your flesh. The sun has been warming for a long time and has now reached the middle of the room and is licking our toes with its tongue, sucking like a new-born calf. I slide onto the floor and ponder how it would be to ferment the sun, like sauerkraut or kimchi. Preserve it to prolong the taste of a scorching hot morning, to press it down inside a transparent jar enriched with the flavours of your preferred morning chamber, firmly secure it with a Mars Red aluminium lid and wait for the rain to drop bodies of water for days on end. I make another dimple halfway on top of the previous one exerting pressure as slow as I possibly can, I go deeper and think of how wonderful it would be to ferment the sun and extend time like chewing gum.

07.00 The coffeemaker starts to growl. The Color of Pomegranates plays in the background.

11.00 Someone is at the door. Still in my pajamas I turn towards the knocks, unsure of what to do. — 'Look, it's the post,' you point at their reflection in the mirror. I am not ready but I should get it.

13.00 I received a package with three new pairs of eyes. I have been hesitant to try other ones, but I scrolled by a good deal and decided to give it a go. I will use them to see if I can get a better understanding of various blotches, impressions, indentions and dimples that I have been making lately. I adjust

* I want to grab hold of the is of the thing. These instants passing through the air I breathe: in fireworks they explode silently in space. I want to possess the atoms of time.
— Água Viva, Clarice Lispector

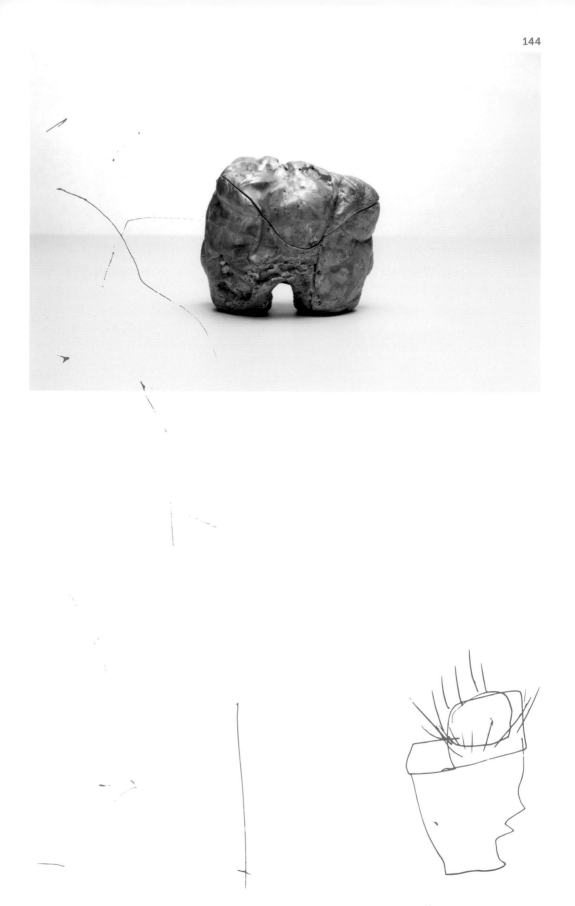

the light. Some marks seem to gradually dissipate which has left me burning to investigate the lot before they level out on me. The eyes come in boxes like a pair of Baoding balls. I take out the first set and think of how they are described, "balls for ball practice" and try rolling them both gently in the palm of one hand. Much like human eyes they aren't supposed to touch each other. The first pair looks much like apricot pearls. I smile, it must be the perfect match for blotches. I replace my own unfocused eyes for the glimmering ball-shaped capsules and immediately jolt back as a stage curtain plummets before my sight and the morning tune is replaced by a splashing roar rising from the depths of the Victoria Falls of Aesthetics. I topple over and get lost in the folds. I see blotches born everywhere and I chase after them before my sweaty face suddenly realises that I'm floating, chasing an iridescent translucent mirage in all its lustrous glory. I am relieved but confused. The blotches seemed real. My palms reflect the touch of Iris as she waters the clouds with her swaying rainbow cape. The drapery sparkles and silver drums define the current beat circulating the air. It's a soothing song but its transparent skin is clouding the stage. How are blotches born? Where do they come from? Where do they go? I start peeling off the skin. Slowly removing the cling film of the mirage. I peel until I learn of The Smoke That Thunders and watch how it reminds the blotches to breath as they perform at the place of the rainbow, dancing on the surface of the earth. Noticing is half the work. I put my hand on the ground and take a rest.

17.00 Impressions appear and moments disappear at the tips of my fingers. The beautiful moment of becoming a lone rider, there for no one. Every clap hits delete. I change for the second pair of eyes and a series of neatly made pinewood boxes appear. Some closed, some half open, different sizes, stacked at random in a corner. I instinctively know that the impressions are there. All of them. There. Inside. Underneath the lid, the bubbles and the wrapping. I can feel them. Breathing in unison with my beating heart. Is it the wrapping that does it? The electricians elastic blue tape that is stretched around? Or the carefully painted picture of shipment? Maybe you can never fully get to them. Perhaps they only exist in transit. The eyes blink. They are possibilities and I know I am close.

Anne Grøtten Viken

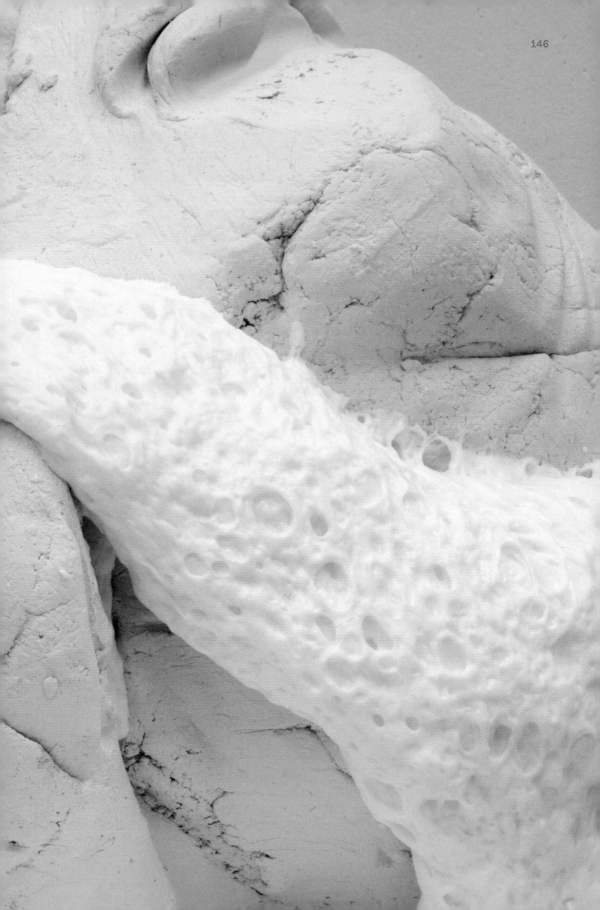

19.00 Early evening and the next tune drifts into my consciousness as it reaches the sunset torched, glazed floor. I place the third pair of eyes in my sockets and a rush of agony flashes before me as a yellow Babel fish swings up from the boiling river, it squirms and wriggles frantically as I grab for its body, desperately searching for the good grip, the indentations that will let me hold it, that won't kill it or let it go. My fingers run over its body in all directions when I suddenly realise that this pair won't grant me vision, but it's already too late. I gasp and the fish slips away instantly and spurts in between the long grass. I jump down on all fours and start to search like mad. I cannot record, transmit or explain the notion of these indentions in any way and now it's too late to even see them. The eyes blanch and roll back. You look at me, I am left in the dark but you simply shrug from between the wrinkles in our sheets and say it looks like I need to pee really badly.

23.00 All eyes are back in their respective cases. Dimples, blotches, indentions and impressions on the floor. Can I still make them? Does everything matter just the same? You told me that I could reproduce them a hundred times and become famous doing just that. I didn't have the heart to tell you that they die. They implode and die. I am tired. I am no longer sure of what I can do with them. These babies cannot grow up. They are a pain. So heavy to drag around, but I'm afraid to let them go because it kills them. You are happy with the dimple in your chin, but you never saw me make it and there is no one left to translate. Mail-order eyes can never show you the real thing. I tape them together, take my t-shirt, cover them in Vaseline and wrap them up. Just like that. You tell me it's great but the fun is gone. What is left when the fun is gone? The sun has settled with the memory of perfectly placed doors in Morocco. You cocoon and I lean back and watch Cimmerians crawl up on my windowsill. The stylus, the diamond on the tip of the needle finds its way through the wavy three-dimensional grooveso of the record and Ceramic Flower is released on its next wave. Such good vibrations. We have starlight after a day of primeo, Goodnight Mr. Echo.

Performance Without A Spectator — Conversation Without An Interlocutor) Nina Fránková by Annee Grøtte Viken

The arpsant day
Annee Grøtten Viken

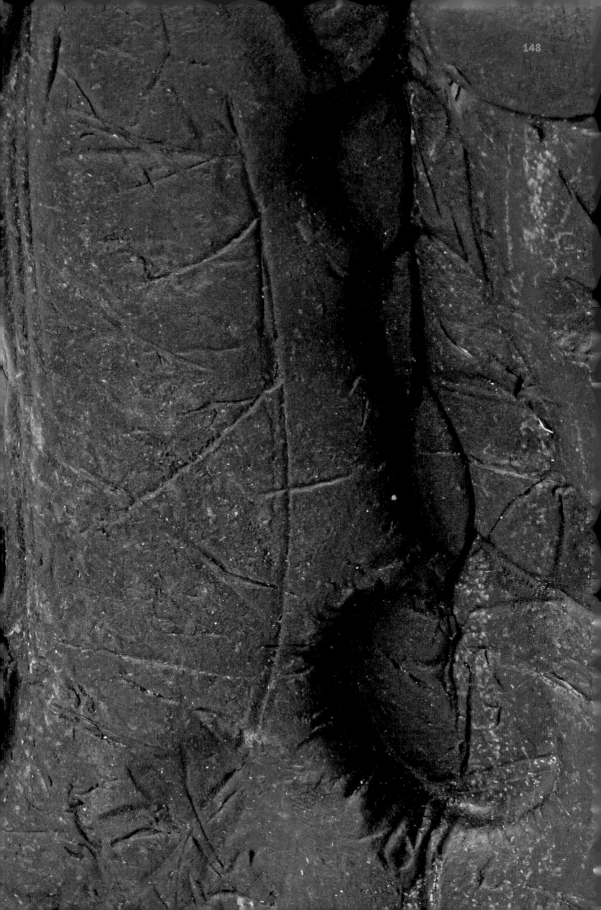

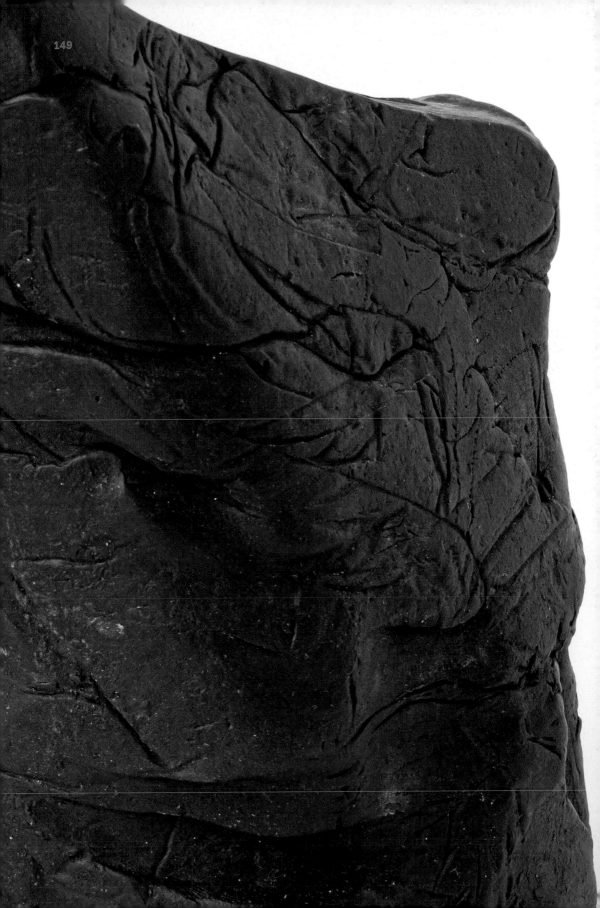

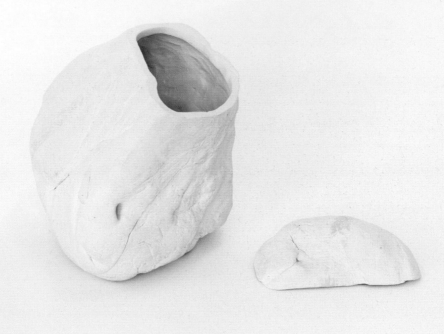

Dream Catcher

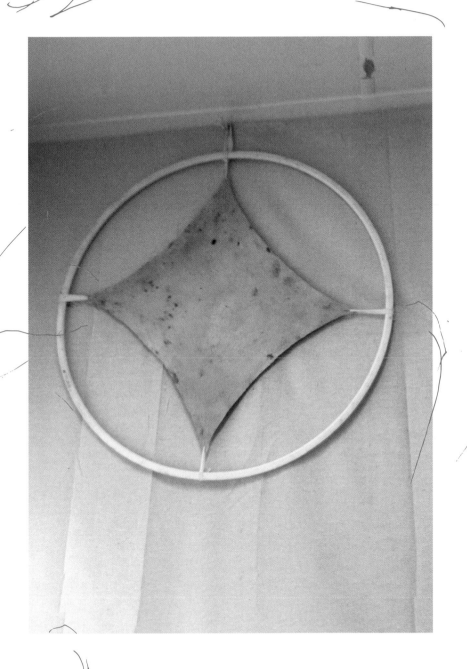

intervention in the studio Set # 2

Dream Catcher

The rag catches dirt

Dreams are the dirt of our minds

The rest remained mixed in
another semi-fictional story

materials: used rags and hula hoop

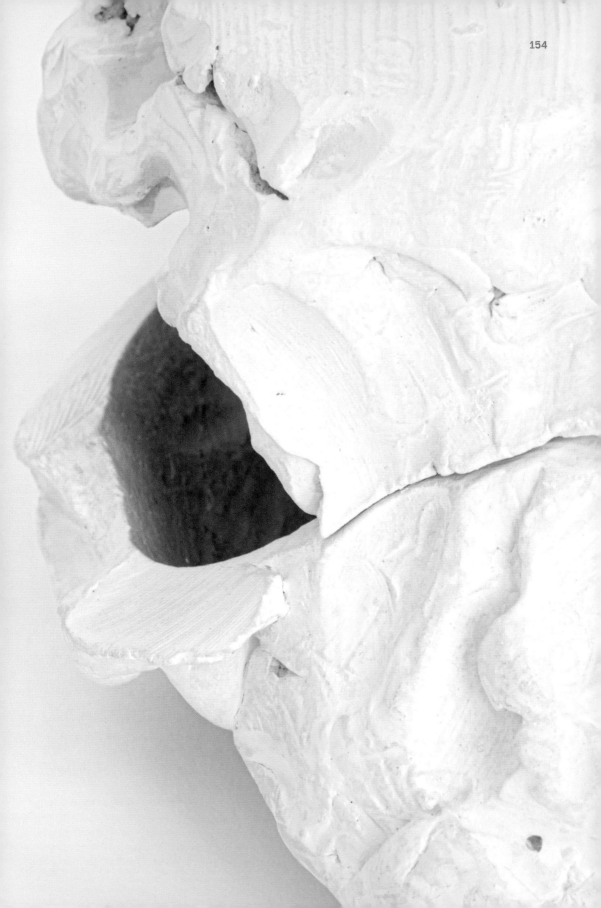

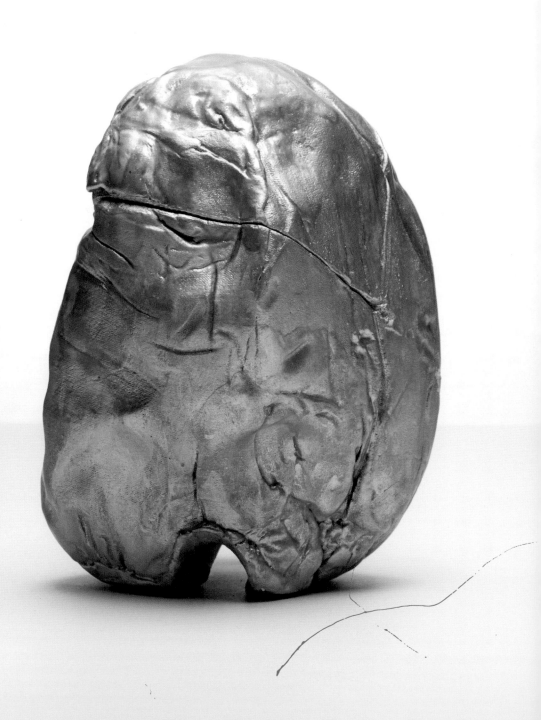

Nina Fránková (CZ) is visual artist and ceramist. Nina works primarily in sculpture, installation and production of porcelain tableware. Having a background in ceramics, she focuses on primeval forms that can be found in nature, and brings attention to what is usually discarded, often showing remnants and traces of work with clay.

For a number of years she resided in Amsterdam where she received a BFA in Ceramics at the Gerrit Rietveld Academy (2012), and a MFA in Fine Arts at the Sandberg Instituut (2014).

Fránková has shown her work and has been artist in residence internationally, in Europe, Asia and the US.

Ott Metusala (EE) is a graphic designer living and working in Amsterdam. Since graduating from Gerrit Rietveld Academie, he has been working on applied and self-initiated design projects in collaboration with artists, writers and institutions based in the Netherlands and Estonia.

Ott is interested in book design, typography and its use in recording knowledge, especially through production and publishing. Currently he is co-manager of the Bookbinding Workshop at the Gerrit Rietveld Academie and recently finished his masters degree at Sandberg Instituut.

Annee Grøtte Viken (NO/BE) is a writer, researcher, artist and restoration architect specialised in traditional decorative painting. Has an interdisciplinary, research-based practice and explores fiction as a tool for approaching, making and understanding space rooted in a keen interest in crafts, materials, heritage and nature. Teaches creative writing and work ranges from writing and publishing to material research, painting, installations, material experiments and architectural works. Enjoys climbing, pines and literary sea stacks.

Kris Dittel is a Rotterdam-based curator, editor and occasional writer. Her recent curatorial research projects include Forms of Kinship, The Voice as Material, and The Trouble with Value. They materialise in the form of exhibitions, books, events, performances and other.

Denisa Kollarová (SK) combines her expertise in graphic design, architecture research and playground design to create interdisciplinary projects. She is based in Amsterdam, and on some occasions in Dessau, Brno and Bratislava. She graduated from Gerrit Rietveld Academie in 2013 and finished her Masters of Science in Design Research in 2018 at Anhalt University of Applied Sciences and Bauhaus Dessau Foundation in cooperation with Humboldt University Berlin.

Kollarová is passionate about studying playground situations as cultural resources around the world. Her work is informed by her past experiences in cultural heritage, especially from her time working in research for the Prince Claus Foundation in Amsterdam and at the BAUHAUS Foundation in Dessau.

She is the founder of the project Seventeen Playgrounds and forms the artistic duo Ancient Acrobatics with Nina Fránková.

Pedro Moraes (BR/IT) is a designer, researcher and writer based between Rio de Janeiro and London where he is a PhD candidate at the Department of Visual cultures at Goldsmiths University of London, with the project 'the continuity between mind and world: towards an idea of artificial general intelligence'. This project seeks to articulate the link between eco-cognitive approaches to the mind with dynamic systems theory so as to formalize a robust framework towards the development of artificial intelligence. He has collaborated extensively with institutions of different scales all over the world and has presented his research in several symposiums in Europe and abroad.

He was previously a researcher at Strelka Institute for architecture and Media and at the HISK.

He presented his work at major exhibition venues such as the 33rd Sao Paulo biennial, Objectif exhibitions, Kunsthalle Wien and CAC vilnius.

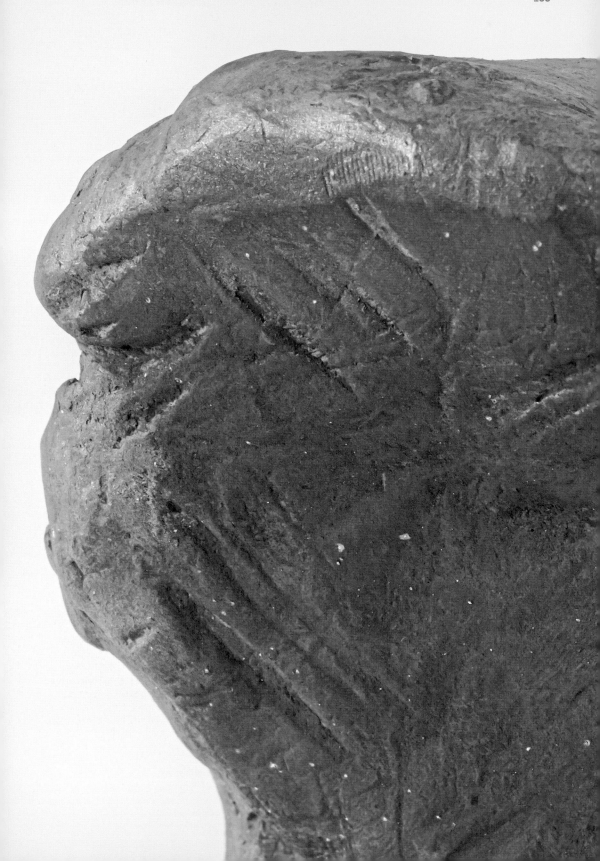

Colophon

Onomatopee Z0036
978-94-93148-71-0

Artist
Nina Fránková

Editor
Amy Gowen

Graphic Design
Ott Metusala

Fonts
Manuka (Benjamin McMillan)
Baltica (Paratype)

Paper
GalerieArt Matt 115 g
Incada Silk 260 g

Printer
Printon (Tallinn)

Edition of 400

Special thanks to Ott Metusala, Amy Gowen, Zdeněk Fránek, Denisa Kollarova, Pedro Moraes, Kris Dittel, Joyce Vlaming, Tibor Fránek, Kim Forni

Photo credits
Enrico Garzaro: pp. 108–109; Šimon Kadlčák: p. 146; Anika Schwarzlose: p. 39; Kaisa Sööt: pp. 89, 100, 153–154; Jonáš Verešpej: pp. 55, 69, 90, 144, 156; Joyce Vlaming: pp. 4, 34–38, 40, 46, 47, 50, 51, 53, 54, 74, 77, 82, 83, 91–95, 98, 99, 102, 103, 106, 107, 110–112, 114–118, 124–126, 128–130, 134, 136–142, 148–150, 154, 158

First edition, 2022

Nina Fránková
www.ninafrankova.ninja

Onomatopee Projects
www.onomatopee.net

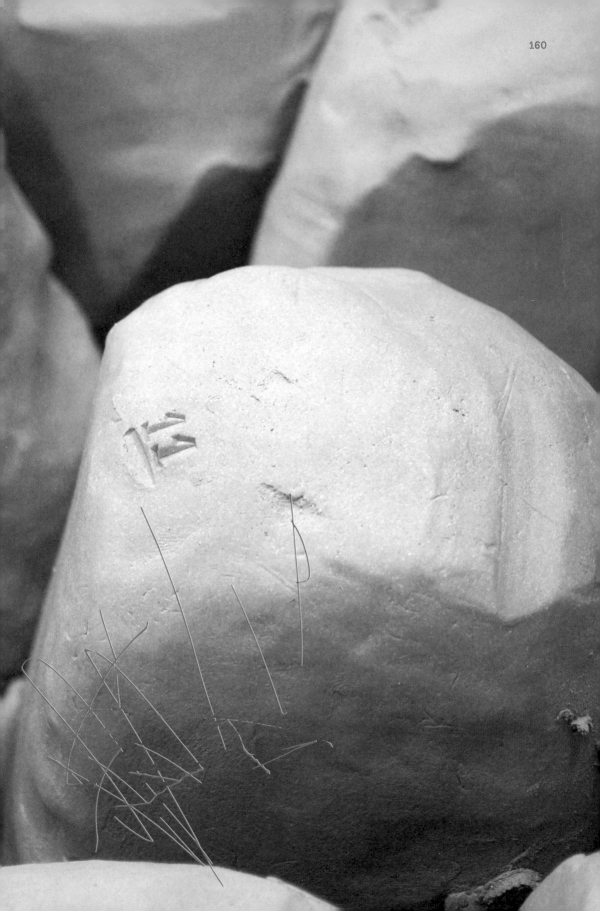